THEN *&* NOW

TAMPA BAY'S BEACHES

Opposite: These bathing beauties taking a romp outside the Palm Pavilion on Clearwater Beach are part of the 1961 Tri-City Suncoast Fiesta. The event symbolized "fun 'n sun" . . . the beaches' past, present, and future allure. The Palm Pavilion in the background was built in 1926 as a bathhouse, where visitors could discard their formal street attire for more daring beach outfits. Today the Palm Pavilion is an informal restaurant and bar, Florida's oldest operating beach pavilion. (Courtesy of Florida State Archives.)

THEN & NOW

TAMPA BAY'S BEACHES

R. Wayne Ayers and Nancy Ayers

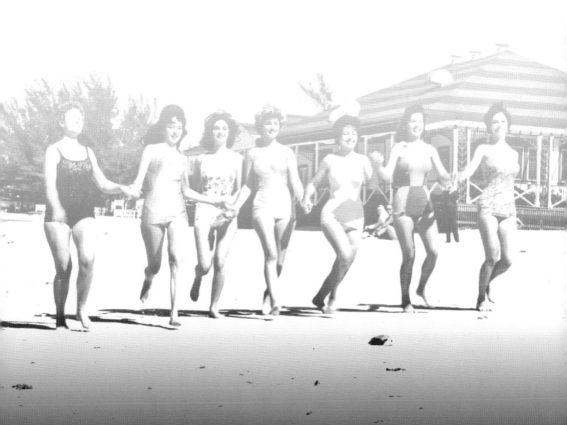

Library of Congress control number: 2007940135

Published by Arcadia Publishing
Charleston SC, Chicago IL, Portsmouth NH, San Francisco CA

Printed in the United States of America

For all general information contact Arcadia Publishing at:
Telephone 843-853-2070
Fax 843-853-0044
E-mail sales@arcadiapublishing.com
For customer service and orders:
Toll-Free 1-888-313-2665

Visit us on the Internet at www.arcadiapublishing.com

ON THE FRONT COVER: The area now known as Sand Key, at the beaches' northern tip, has undergone dramatic changes since the City of Clearwater decided in the 1980s to sell the land for development. (Courtesy of Florida State Archives.)

ON THE BACK COVER: An umbrella for shade and an inner tube to stay afloat were part of a fun day on the beach at Pass-a-Grille in 1926. (Courtesy of Tampa–Hillsborough County Public Library System.)

CONTENTS

Acknowledgments vii

Introduction ix

1. St. Pete Beach Including Pass-a-Grille 11

2. The Mid-Beaches:
Treasure Island, Madeira Beach, and the Redingtons 29

3. Indian Rocks to Sand Key 55

4. Clearwater Beach 81

ACKNOWLEDGMENTS

The authors consulted a number of sources in preparing the introductory section and captions for this book. The following books were especially helpful and are recommended to anyone desiring a more in-depth look at the heritage of the beach communities.

Hurley, Frank T., Jr. *Surf, Sand, and Post Card Sunsets: A History of Pass-a-Grille and the Gulf Beaches*. St. Petersburg Beach: Hurley, 1977.

Indian Rocks Historical Society. *Indian Rocks As It Was: A Pictorial History*. Indian Rocks Beach, FL: IRB Publishing, 2006.

Sanders, Michael L. *Clearwater: A Pictorial History*. Norfolk: The Donning Company, 1983, 1997, 2000.

VanKuiken, Sally A. and Christian J. Buys. *Historic Pass-a-Grille: Paradise Still*. Lake City, CO: Western Reflections Publishing Company, 2006.

The authors wish to thank the following organizations and individuals for their generous support in providing historical images for the book: Heritage Village Archives and Library, Florida State Archives, Tampa–Hillsborough County Public Library System, Indian Rocks Historical Society, Clearwater Historical Society, Treasure Island Historical Society, Belleair Beach City Hall, Madeira Beach City Hall, Church by the Sea, Candy Kitchen, Arnold Alloway, Tony Antonious, Jerry Cook, Dottie Miller, Jabo Stewart, and Bill Wallace.

All modern images were taken by Nancy Ayers except for aerial photographs that are courtesy of J. Cook Photographics Inc. Images from the past are from the authors' personal collection unless otherwise indicated.

INTRODUCTION

Change and renewal has been a constant along Tampa Bay's beaches from the times of its earliest recorded past. Periods of change on the beach have been gradual at times, accelerated and startling at others —not unlike the tides that sweep the shore in varying intensities. Dramatic and lasting changes have resulted from both natural calamities and man-made occurrences. Passes have been created by hurricanes in a few hours, while condominium developments have altered the face of communities in the space of several years.

Virtually no location along the beach strip from Pass-a-Grille to Clearwater Beach has remained unchanged over the recent past. The insatiable demand for coastal property has made change a by-product of life on the barrier islands.

The many faces of change along Tampa Bay's beaches makes a "then and now" comparison especially fascinating. Many wonder, "What was here before my condo was built?" or "What did the beach look like 50 years ago?"

The pace of change has been uneven along the beach strip. Pass-a-Grille, at the southern tip, still maintains much of its early 1900s appearance. Structures in the Eighth Avenue business district remain Old Florida and would be recognizable to a visitor transported from 1910. The business mix, however, has been updated to an eclectic blend of art galleries, boutiques, and trendy eateries. Many vintage cottages still line the shaded streets and alleyways of the blocks-long historic district.

The Corey Avenue business district in nearby St. Pete Beach also retains much of its 1950s character, while top attractions of yesteryear like the Aquatarium and London Wax Museum have long departed. The classic Don CeSar Hotel, a product of the 1920s, stands proudly today as a splendidly restored, world-class property.

At Treasure Island, the motel was—and is—King, although the condo-hotel is an ongoing takeover threat. Here the post–World War II tourist boom still lives in the art deco shopping area at the causeway entry and classic motel properties like the imposing Thunderbird, the Arvilla, Algiers, and a number of others. A condo-hotel stands where the swank Surf once welcomed visitors, but the Bilmar is being rebuilt from the inside out, maintaining its vintage character. The shell mix offered at the Florida Shell Shop has taken a more exotic bent since the 1950s, although the standby conches, whelks, and sand dollars are still big sellers.

John's Pass Village blends the old and newly old in its continuing quest to meld Florida Cracker-style quaintness with expanded shops and services. The Pass's deep-sea fishing heritage is still evident in the charter boats that depart daily from the marina. More popular today though are grouper dinners served with a water view and an assortment of cleverly themed T-shirt and souvenir places.

Madeira Beach proclaimed itself Florida's Fastest Growing Resort City in billboards beckoning tourists to the area in the 1950s. The city grew so fast that it ran out of land by 1957. Residential lots were

created from sand dredged from the Intracoastal Waterway. The idea became so popular, and profitable, that most waterfront property is the result of dredging operations.

Madeira Beach's fishing village heritage is mostly gone, supplanted in the postwar years by tourism and later by waves of retirees seeking a condo in the sun. The business district that once spread out along Gulf Boulevard has given way to hulking condominium buildings on the beach side. Little of historic significance remains, although the retail shops bordering Madeira Way are 1960s vintage. That area is slated for redevelopment into a pedestrian-friendly enclave featuring plenty of greenery and, presumably, tourist appeal.

The Redingtons (now Redington Beach, North Redington Beach, and Redington Shores) was a lonely parcel of land prior to the arrival of Charles Redington in the 1930s. Redington built the Tides Hotel and Bath Club in 1939 to call attention to his forlorn property. His bringing of world-class (for the day) resort amenities to a secluded yet beautiful stretch of beach was an instant hit with celebrities as well as socially prominent locals. The list of rich and famous that visited the resort included actor Tyrone Power, filmmaker Alfred Hitchcock, movie star Ronald Reagan, and the duo of Marilyn Monroe and Joe DiMaggio. Local celebrities such as the Webb's City mermaids and regional beauty queens also rubbed shoulders with vacationers from Des Moines and Cincinnati.

Today some of the former guests have settled down in the Tides Condominiums on the site. Down the way, the old Redington Long Pier still attracts fishermen and sightseers to the last wooden fishing pier left on the barrier islands.

A railroad link to Tampa spurred tourism and an early-20th-century real estate boom in Indian Rocks, later called Indian Rocks Beach. The spur that ran across the waterway onto the barrier island gave droves of Tampa residents access to cooling Gulf breezes. Vacationers in the wooden hotels along the shore became part-time residents as real estate developers offered cottages in newly platted waterfront subdivisions. A number of the unique beach cottages survive, as do some of the buildings that housed businesses serving newcomers.

In Indian Shores, formerly Indian Rocks Beach South Shore, Tiki Gardens was the big draw. The attraction recreated a South Seas paradise and drew over 300,000 visitors a year during its heyday.

Belleair Beach served as a target range for World War II bombers, who came over on runs from Tampa's MacDill Air Force Base. Opening of the Belleair Beach Causeway in 1950 transformed the former palmetto scrub wasteland into an enclave of single-family ranch-style residences and a scattering of beachfront motels. The almost exclusively residential character of the area continues, although multistory "McMansions" have replaced a number of the more modest waterfront homes.

The grand Belleview Biltmore hotel, built in the late 1800s by developer Henry B. Plant, presides over a prime bluff site overlooking Clearwater Bay. The picturesque, rambling hostelry has survived demolition threats and continues to welcome visitors who sometimes report seeing ghosts roaming its corridors.

Clearwater Beach, at the northernmost edge of the beach strip, has long boasted of its expansive public beach, rated among the state's finest. A rickety auto bridge, opened in 1916, made the beach accessible to adventurous excursionists who tooled their Model T's over for a shore outing. The vintage Palm Pavilion, now an informal bar/eatery, has served beachgoers since its heyday as a bathhouse in the 1930s and 1940s. Heilman's Beachcomber serves updated versions of the 1950s favorite "Down on the Farm" chicken dinner from its original location. Mom-and-pop motels lined the bay front until a recent condominium development surge put most under demolition orders.

Extension and development of the Pier 60 complex in 1962 gave the area a focal point and became the entryway for visitors to enjoy the wide and extensive public beach, which remains the major attraction.

St. Pete Beach Including Pass-a-Grille

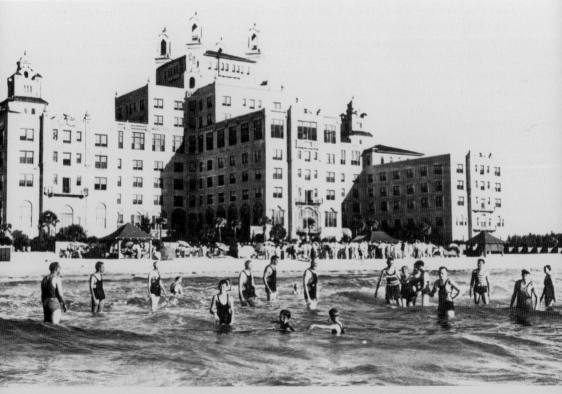

Development on the beaches during the first boom era was capped by the construction of the grand Don CeSar Hotel in 1926. The $1.5-million "pink lady" epitomized the real estate euphoria of the times, which vanished during the Depression. The Don's resurrection as the grandest structure on the beaches in the early 1970s spurred interest in historic preservation, helping Pass-a-Grille to retain much of its early architecture and charm. (Courtesy of Florida State Archives.)

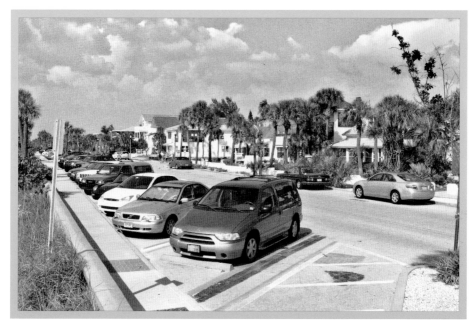

Boardwalks were a popular beachside attraction in many resort communities. The planked walkways were a popular venue for promenading or simply relaxing in the sun. Formally dressed Victorians could enjoy the sea's delights without the bother of picking a course among shifting sands and dune vegetation. A few of the original beach cottages remain in the view looking north along Gulf Way.

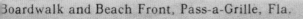

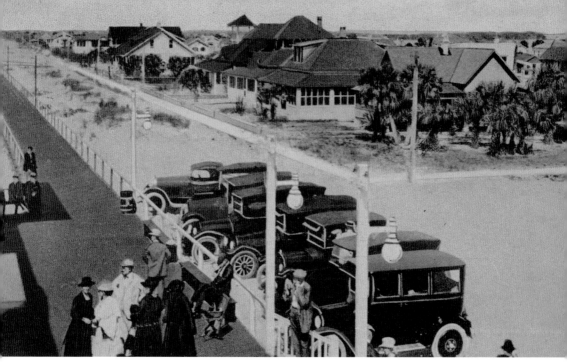

Boardwalk and Beach Front, Pass-a-Grille, Fla.

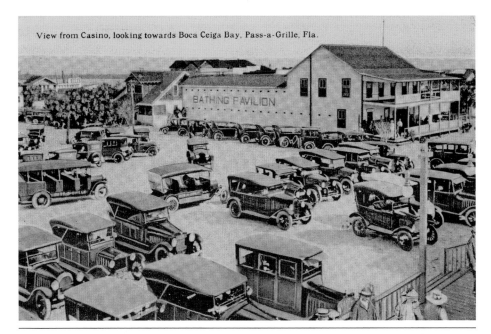

View from Casino, looking towards Boca Ceiga Bay, Pass-a-Grille, Fla.

Bathhouses, once a common sight along the shoreline, offered beachgoers a place to change from their street clothing into bathing attire. Page's Bathing Pavilion was built in 1905 by Charles S. Page and was Pass-a-Grille's first such establishment. The classic wooden structure hosted a number of businesses over the years before it was torn down in the 1960s. Today the faux-Victorian Hurricane restaurant, with its popular rooftop deck, is again attracting customers to the site at Gulf Way and Ninth Avenue.

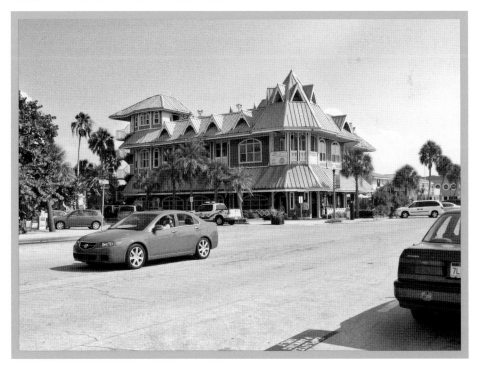

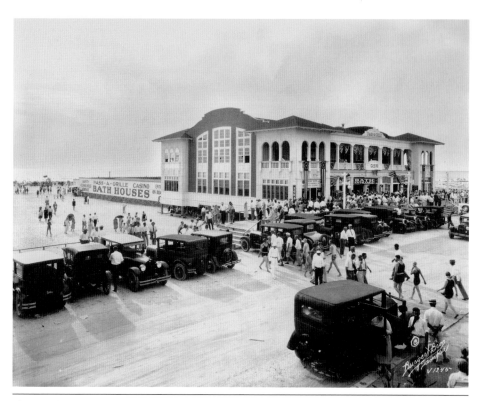

The Seaside Grille now sits where the landmark Pass-a-Grille Casino once stood. The casino served as a bathhouse and center for social activities and was usually jammed with excursionists during its heyday in the 1920s. Gambling was never a part of the casino's activities, but bootleg liquor was readily available during the Prohibition era. The massive wooden structure was later converted to become the Pass-a-Grille Beach Hotel. It was destroyed by fire in 1967. (Courtesy of Tampa–Hillsborough County Public Library System.)

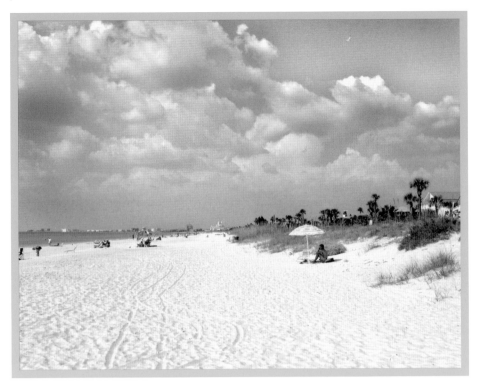

Stands of Australian pines covered the Pass-a-Grille peninsula from the early 1900s, when they were imported as a windbreak, up until the 1960s, when freezes mostly wiped them out. The Don CeSar can be seen in the distance in this view looking north. Renourishment and the installation of a jetty around 1960 have widened the beach considerably, and the Australian pines have been replaced by native palmetto palms and sea grasses.

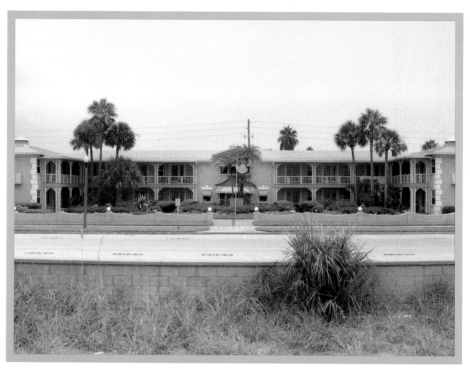

"Just picture me with a Coke and a sunburn—and my typewriter. It's lovely down here," reads the inscription on this photo card mailed from Pass-a-Grille Beach in 1948. The writer goes on to describe her apartment as "sweet and comfortable." Accommodations such as the Cameo Apartments often featured suites of several rooms that appealed to extended-stay visitors. It became time-sharing condominiums in 1982 and was renamed Camelot by the Sea. (Courtesy of Heritage Village Archives and Library.)

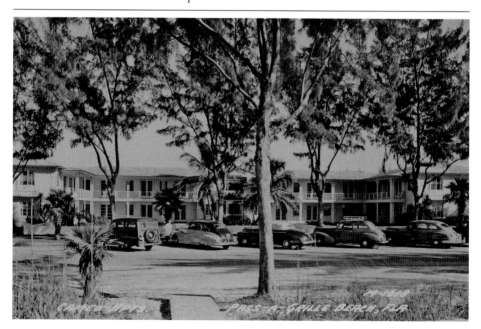

St. Pete Beach Including Pass-a-Grille

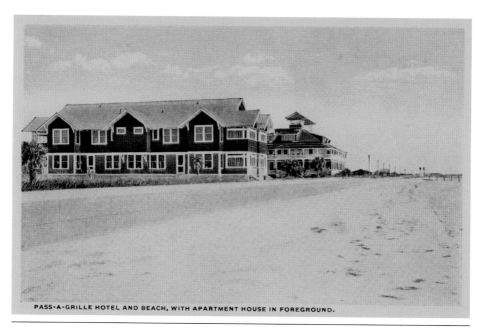

PASS-A-GRILLE HOTEL AND BEACH, WITH APARTMENT HOUSE IN FOREGROUND.

The Butler House originally housed hotel employees as well as guests' servants from the adjacent Pass-a-Grille Hotel. The building was the only structure saved when the hotel burned to the ground in 1922. It was then converted to apartments, a use it has held ever since. Harry Butler purchased the building in 1940, changing the name from Patterson Apartments to Butler House. (Courtesy of Florida State Archives.)

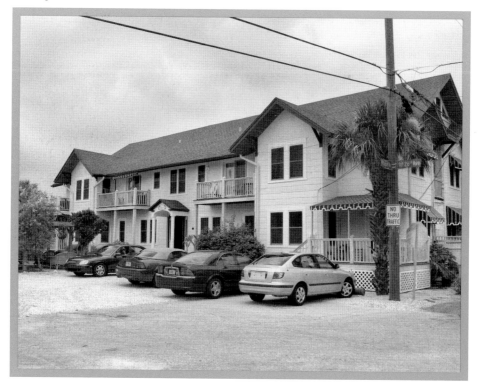

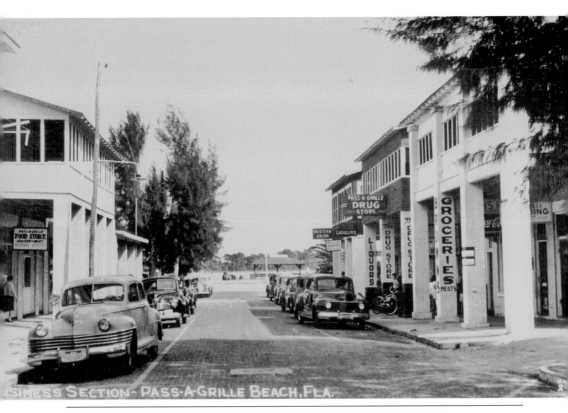

Buildings lining Pass-a-Grille's Eighth Avenue business section have remained virtually unchanged since their construction in the early 1900s. Their uses, however, have changed dramatically. The 1940s scene includes grocery and drugstores, a rooming house, Western Union telegraph office, and a barbershop. The structures are today painted in fashionable Key West shades and the businesses updated to a trendy mix of bistros, eateries, and boutiques.

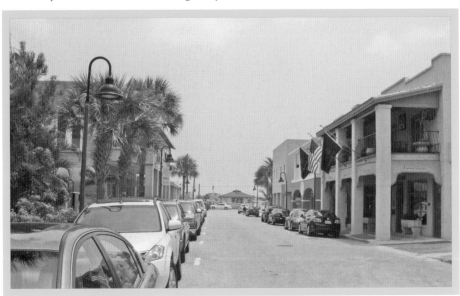

St. Pete Beach Including Pass-a-Grille

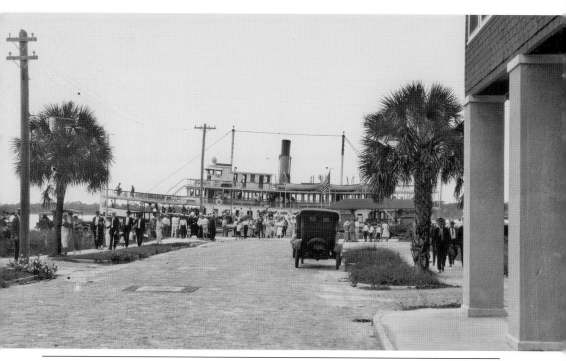

The Merry Dock at the foot of Pass-a-Grille's Eighth Avenue "main street" was the town's entry point and transportation hub in the early 1900s. Passenger steamers, such as the *Favorite* pictured here in 1924, brought visitors to the island retreat from St. Petersburg, Gulfport, Tampa, and other ports of call. Today the Merry Pier provides docking space for tour boats and fishing charters. Pleasure boaters embark to visit the town's boutiques and galleries and feast on freshly caught shore dinners. (Courtesy of Tampa–Hillsborough County Public Library System.)

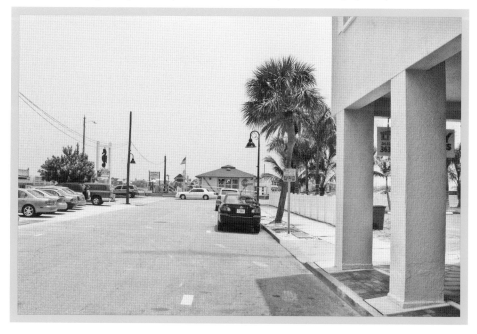

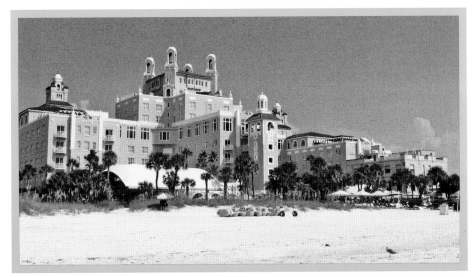

The Don CeSar was the first grand luxury hotel constructed on the beaches. Built in 1926 by developer Thomas Rowe at a cost of over $1.5 million, the project was considered somewhat of a gamble. The pink castle by the sea proved to be an instant hit with society's rich and famous, and it was a love affair that lasted until World War II. Stints as a Veteran's Administration hospital and offices followed, as the hotel suffered a long and steady decline. In 1973, the Don CeSar was resurrected and transformed into today's world-class beach resort.

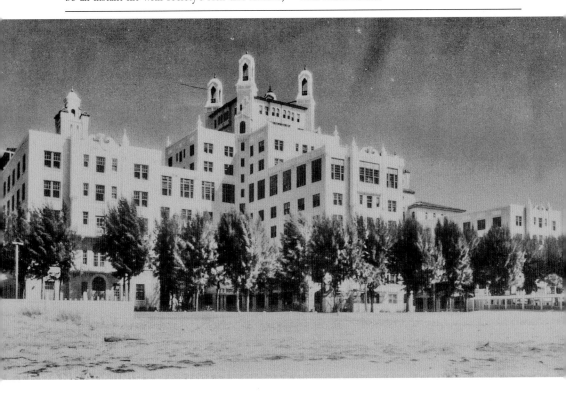

The multimillion-dollar Aquatarium, built in 1964, billed itself as the world's largest marine show. The attraction featured two exhibit tanks, including a futuristic geodesic dome and a main aquatic tank holding over a million gallons of water. Standing-room-only crowds often gathered to watch the dolphin and sea lion acts during the Aquatarium's 24-year run. Competition from Busch Gardens and the Disney parks forced the attraction to close in the late 1970s. The Silver Sands Beach and Racquet Club condominiums now occupy the Aquatarium's 18-acre site. (Courtesy of Florida State Archives.)

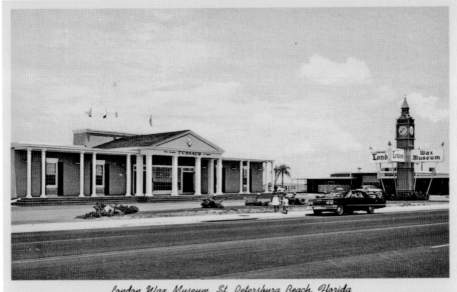

London Wax Museum, St. Petersburg Beach, Florida

Wax museums were a sign of arrival for resort communities in the 1960s. St. Petersburg Beach's London Wax Museum touted realistic likenesses of over 100 famous characters of the past and present. Local entrepreneur Ted Stambaugh owned and managed the London Wax Museum, which was identified by the Tower of London replica fronting the site at 5505 Gulf Boulevard. Today Rob and Debbie Stambaugh operate Silas' Steakhouse on the property.

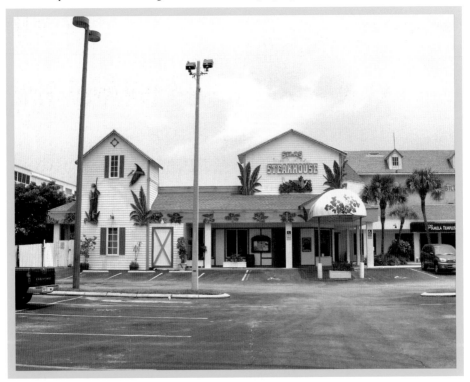

ST. PETE BEACH INCLUDING PASS-A-GRILLE

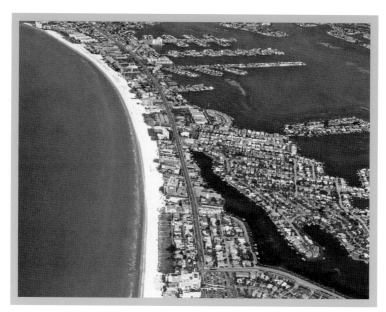

The view looking north from the Don CeSar in 1930 shows why the grand hotel was referred to as "the lonely sentinel" in its early days. Population surged in the years following World War II, as thousands of baby-boom families arrived in their automobiles for an extended vacation in the sun. Today the area is jammed with development—the only vacant land being the beach. ("Now" courtesy of J. Cook Photo.)

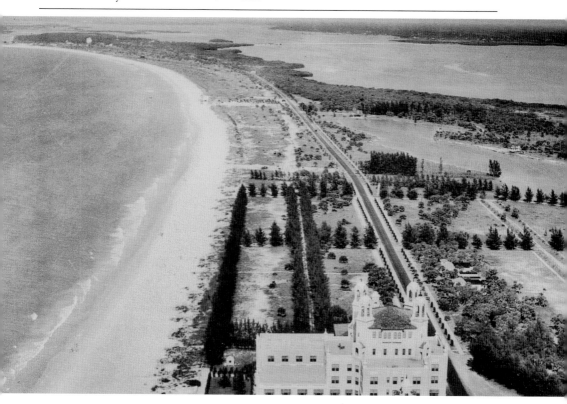

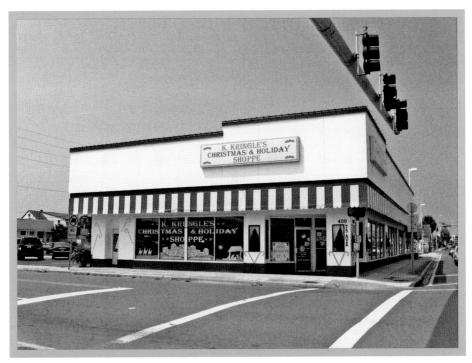

Robert "Doc" Lamb became the first pharmacist in St. Petersburg Beach when he opened Lamb's Pharmacy at 400 Seventy-fifth Avenue in 1950. For 25 years, Lamb dispensed practical advice to his customers as he filled their prescriptions. One former customer described him as being straight out of a Norman Rockwell painting. Kris Kringle's Christmas Shop now occupies the building at Seventy-fifth Avenue and Blind Pass Road. Lamb's daughter, Roberta Whipple, is director of the nearby St. Pete Beach Library.

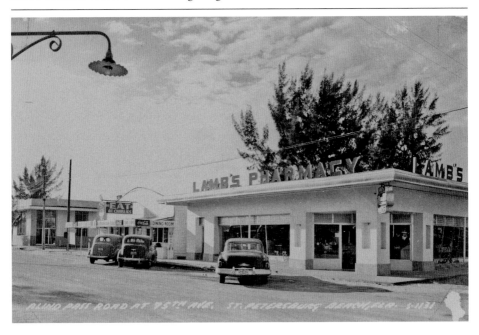

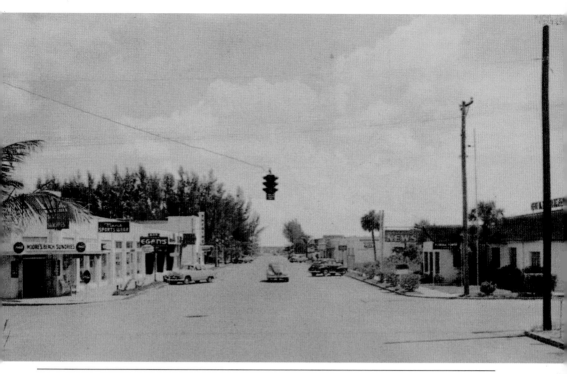

Corey Avenue has been St. Petersburg Beach's "main street" since the late 1930s, when local real estate developer William Upham laid out the street and built the first stores. Business was booming by the 1950s as postwar prosperity brought hordes of tourists and new residents to the area. The current Corey Avenue business district is an eclectic mix of boutiques, trendy eateries, and antique shops. A downtown landmark, the Beach Theatre at 315 Corey Avenue, has recently been renovated to attract new generations of moviegoers.

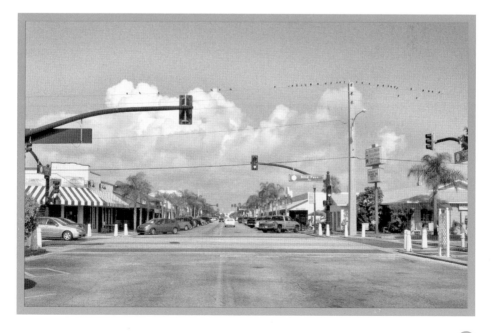

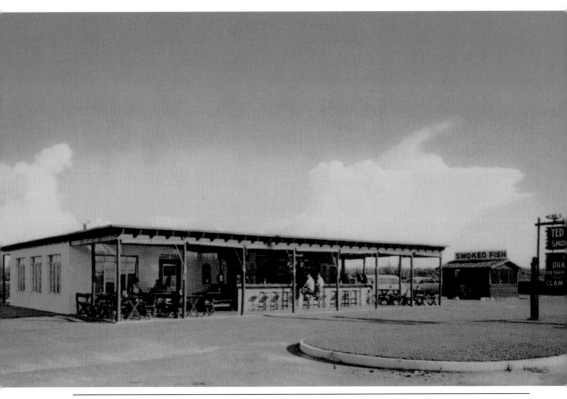

Hungry tourists once sought out Ted Peters Famous Smoked Fish at his isolated location on Pasadena Avenue "over the causeway." The locale was described as "a peaceful setting at the gateway to the Gulf Beaches." By the mid-1950s, Peters was smoking over 100,000 pounds of fish a year. The St. Petersburg institution has changed little over the years. Smoked mullet remains a specialty, and the smokehouse is still on premises. Now fronting six-lane Pasadena Avenue, Ted Peters's setting can no longer be classified as peaceful.

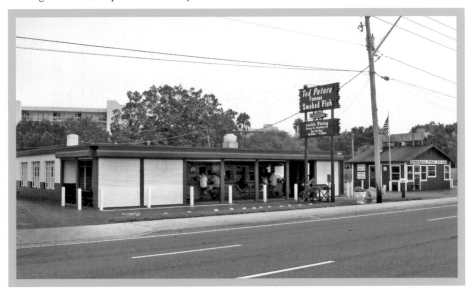

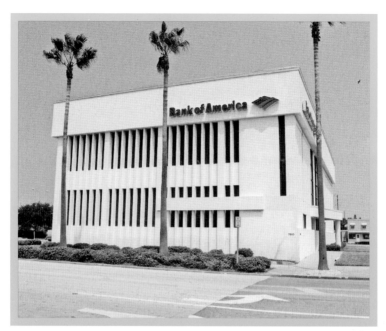

The Bank of America building at Seventy-fifth Avenue and Gulf Boulevard stands at the site of the Gulf Beach Bank, constructed in 1921 by pioneer real estate tycoon W. D. McAdoo. McAdoo reportedly claimed to have built the five-story structure "because there isn't a bank in Florida big enough to hold all of my money." For unknown reasons, McAdoo did not qualify for a bank charter. The building stood almost empty until 1948, when the Gulf Beach Bank finally opened its doors. (Courtesy of Heritage Village Archives and Library.)

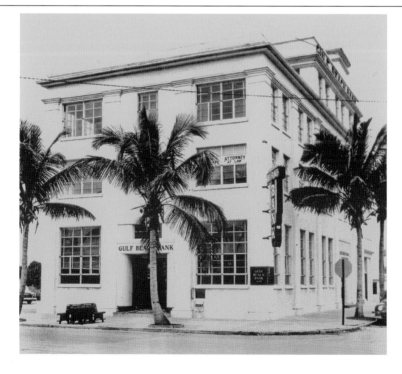

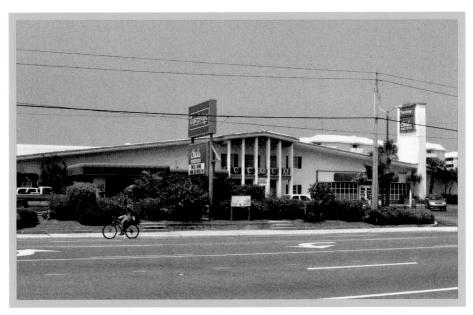

Comedian Lenny Dee entertained regularly in the lounge and New York Mets players roamed the corridors of the Colonial Inn in the heyday years after its opening in 1957. The upscale motel, located at 6300 Gulf Boulevard, quickly gained popularity due in part to its close proximity to the famed Aquatarium. Financial factors prompted the Travelodge affiliation in 1999, and the signature horse and carriage replica on the front lawn was moved to Willow Tree Nursery in St. Petersburg. (Courtesy of Florida State Archives.)

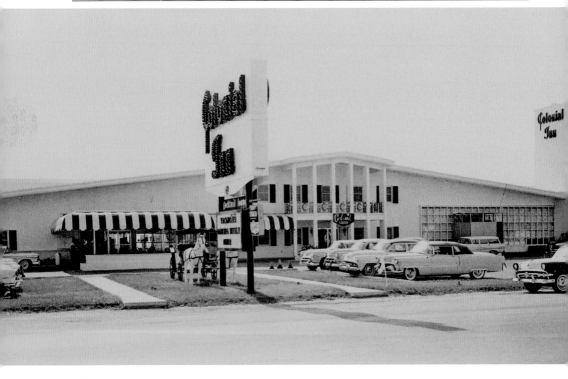

CHAPTER

THE MID-BEACHES

TREASURE ISLAND, MADEIRA BEACH,

AND THE REDINGTONS

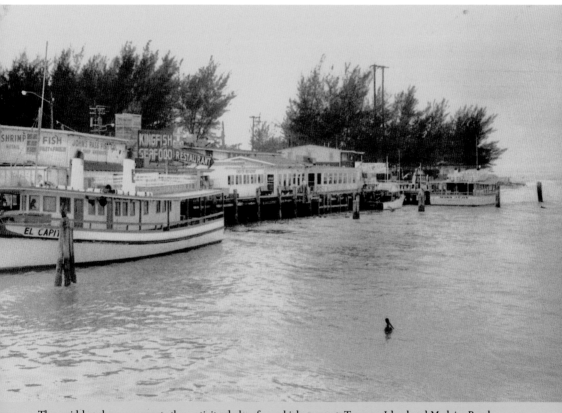

The mid-beaches represent the activity hub of Tampa Bay's beaches, and the epicenter of the action is focused on John's Pass. In the early days, the deep-sea fishing fleets were headquartered at the pass, which connects Treasure Island and Madeira Beach. Recent years have seen the emergence of John's Pass Village as the beaches' prime tourist attraction. (Courtesy of Arnold Alloway.)

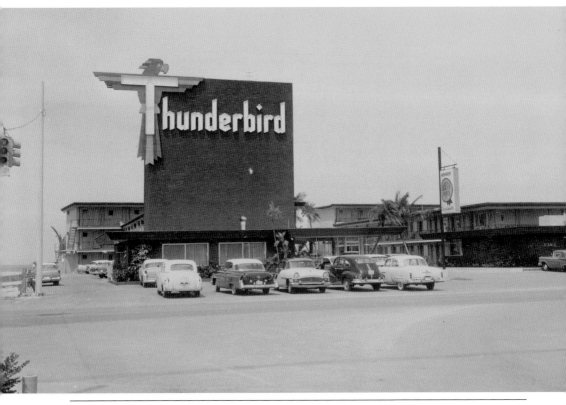

The Thunderbird motel, no doubt a namesake of the 1950s auto icon, has long dominated the causeway entry to Treasure Island. The classic "T'bird" featured all the 1950s motel amenities—drive-up accommodations, swimming pool, television, and air-conditioning. The imposing monument sign, about six stories high, remains a landmark to this day. (Courtesy of Florida State Archives.)

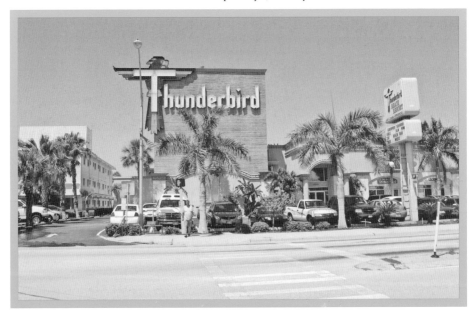

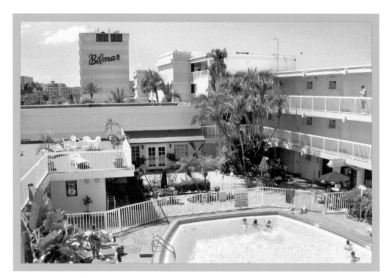

Putt-putt, or miniature golf, was the rage during the 1950s and 1960s, and the Bilmar motel boasted a private course for guests. The classic property was opened in 1961 by Russell and Connie Baltz, who named it after their children Bill and Margot. The Baltz family sold the property in 2000 to a management company for conversion to a condo-hotel. The original architecture was preserved in the renovation. The Bilmar name remained also, as the parents of a principal owner were named Bill and Marion.

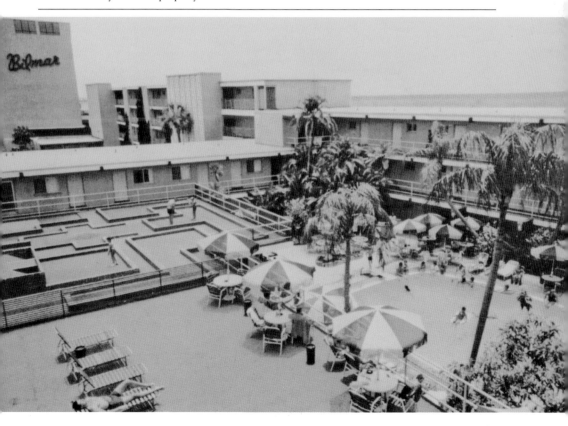

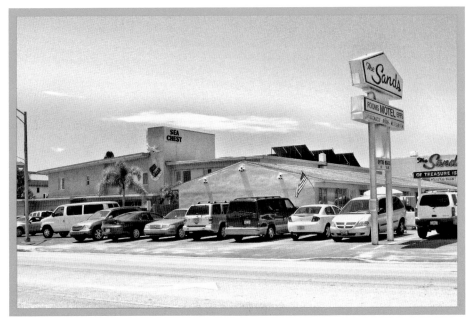

The motel was, and remains, king in Treasure Island. The city's motel era began in 1947 with the construction of the Sands. A fairly modest property by later standards, the Sands was the genesis of a motel-building spree in the city. By the mid-1950s, the Treasure Island shore was filled with motel accommodations ready to house the influx of newly minted baby-boom families arriving for a "cool, man, cool" vacation. (Courtesy of Heritage Village Archives and Library.)

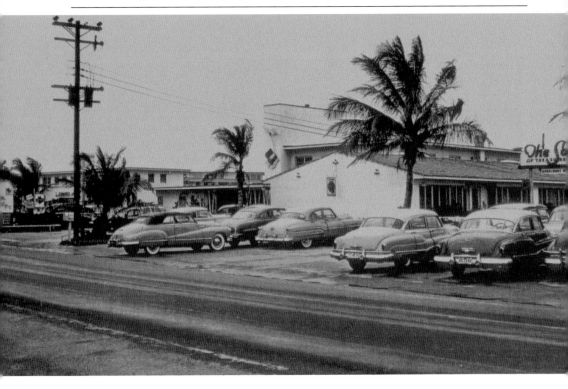

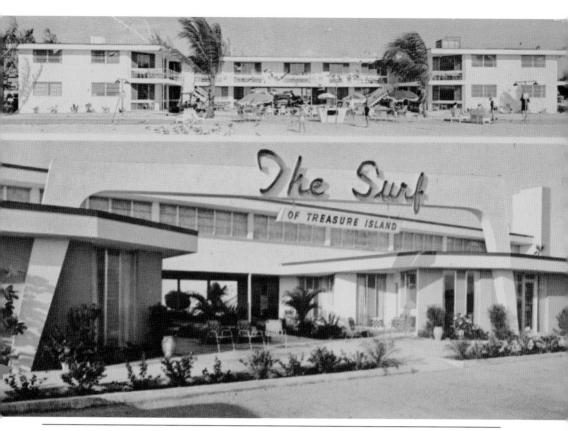

Construction of the Surf, located at 11040 Gulf Boulevard, followed the Sands in the early 1950s and touched off a motel building frenzy that soon established Treasure Island as "the heart of the Holiday Isles," as its chamber of commerce proclaimed. The Surf was a prototype for the swank, upscale motel that offered deluxe amenities such as air-conditioning, television, and a heated pool. It was demolished in 2004 to be replaced by the hottest development type of the current age—a condo-hotel.

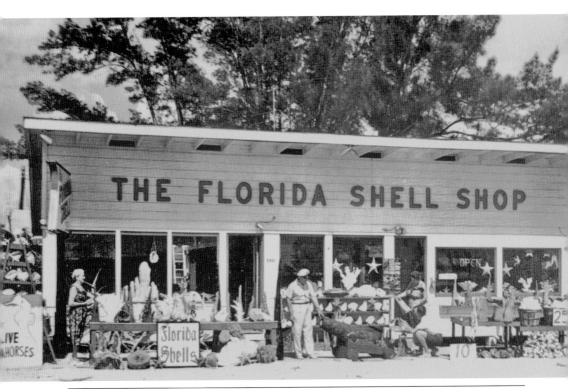

Baby-boom families visited the Florida Shell Shop to let their kids put conches to their ears and to hear the sea roar. Native shells of many types were featured along with the obligatory pet to take home—in this case a live seahorse. Today the Florida shells have been supplemented by exotics from oceans worldwide, and living seahorses are passé. Still, the Florida Shell Shop remains true to its mission of nearly 60 years: providing authentic, natural specimens of the state's signature souvenir. (Courtesy of St. Petersburg Museum of History.)

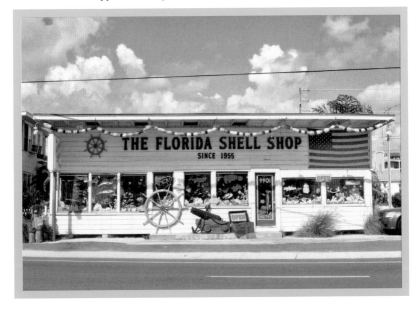

The 10 beach municipalities were all incorporated during the 1940s and 1950s postwar growth surge. Treasure Island was officially created on May 3, 1955, by a merger of the towns of Boca Ciega, Sunset Beach, Sunshine Beach, and the city of Treasure Island. Boundaries of the original Treasure Island, which had existed since 1937, were 104th Avenue and 119th Avenue. The photographs show Treasure Island City Hall with city employees standing in front in 1966 and a tree-shaded view today. (Courtesy of Treasure Island Historical Society.)

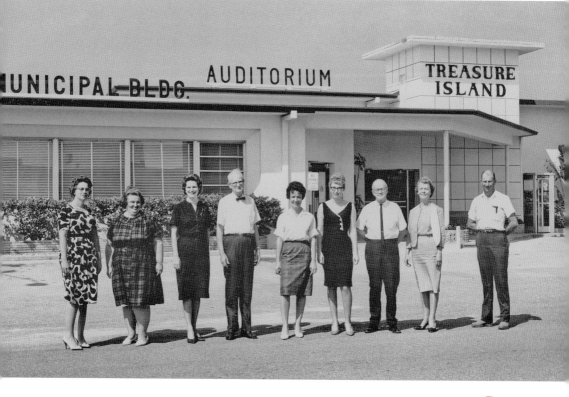

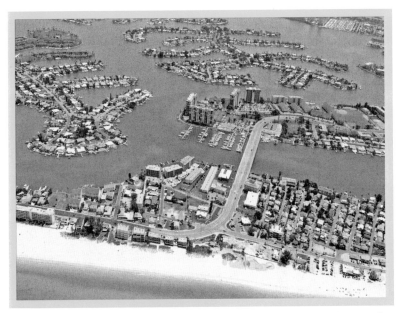

Looking from Sunset Beach to St. Pete Beach over Blind Pass, these comparative aerial views show the transformation that has marked Treasure Island since 1945. Low-rise condominiums and single-family homes have filled in the mangroves and Australian pine forests dominant on the barrier island. The fingers of land in the Intracoastal are the sand dredgings that have become the Paradise Island and South Causeway Isles subdivisions. The photographs' primary constant is Blind Pass Bridge, now widened. (Above, courtesy of J. Cook Photo; below, Heritage Village Archives and Library.)

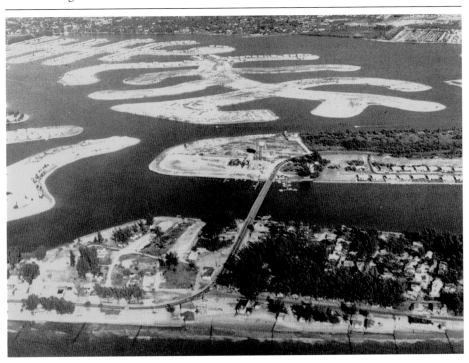

The Penguin on Sunset Beach had a long and somewhat checkered role in Treasure Island's past. Originating in 1939 as the Penguin Beach Club, the facility offered a bathhouse and fishing, as well as full-service dining. A second Penguin restaurant was built in 1945 after the first structure was destroyed by fire. That facility was in turn destroyed by Hurricane Agnes in 1972. An igloo-shaped building came next, followed by a bar. In 2003, the city built its gateway public park and pavilion on the site. (Courtesy of Treasure Island Historical Society.)

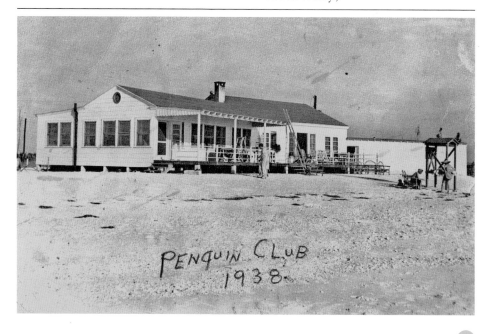

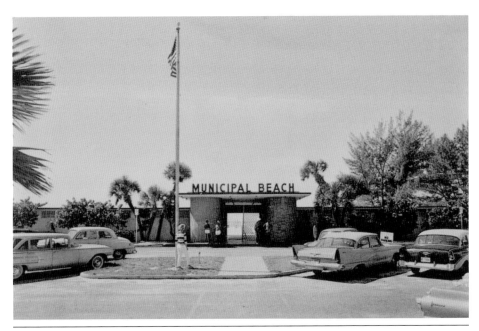

St. Petersburg residents are sometimes surprised to learn that the city owns and operates a public beach in the neighboring gulf beach community of Treasure Island. City fathers purchased the property outside the city limits years ago to ensure residents would have access to the beach for generations to come. Today St. Petersburg Municipal Beach offers city residents as well as others a wide and well-maintained beachfront with a pavilion and refreshment stand.

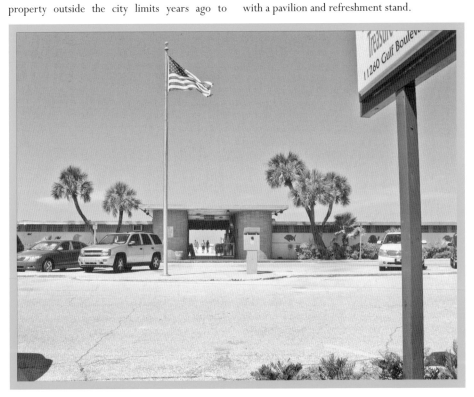

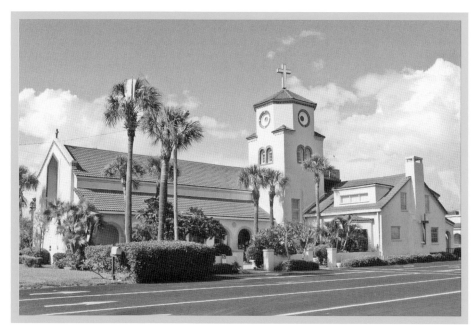

The landmark Church by the Sea is sometimes known as "the fishermen's church." The church was founded in the 1940s by a group of John's Pass fishermen seeking a place to worship. Weekly fish fries were held to raise funds for the building materials. A lighted beacon that once stood atop the church tower was kept burning nightly until the last fishing boat had safely returned. Today the Church by the Sea remains a vibrant community place of worship. (Courtesy of Church by the Sea.)

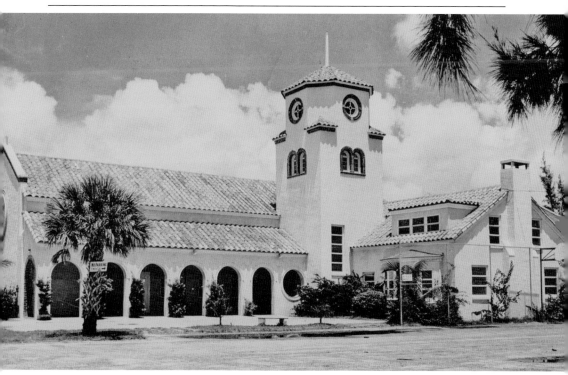

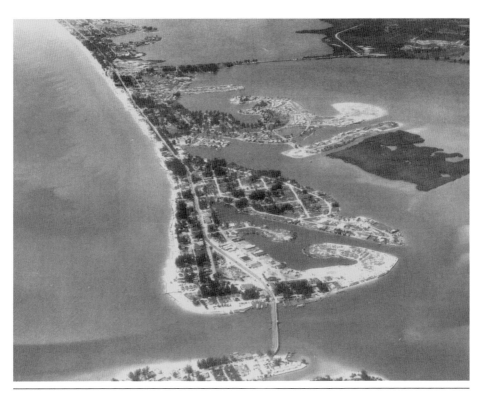

John's Pass, at the bottom of these photographs, is best known today for John's Pass Village on the north side of the pass. The famous Gators restaurant and bar is located just off the bridge on the south side. In 1951, Madeira Beach remained a sleepy fishing village, and John's Pass was headquarters for the deep-sea boats. The bridge connecting Treasure Island with Madeira Beach was relocated to the west, nearer the gulf, in 1971. (Above, courtesy of Jabo Stewart; below, J. Cook Photo.)

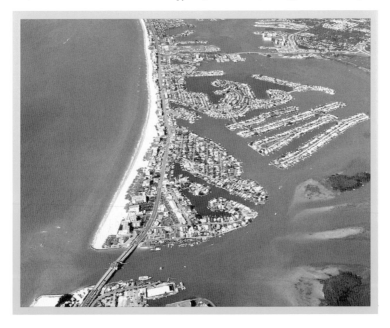

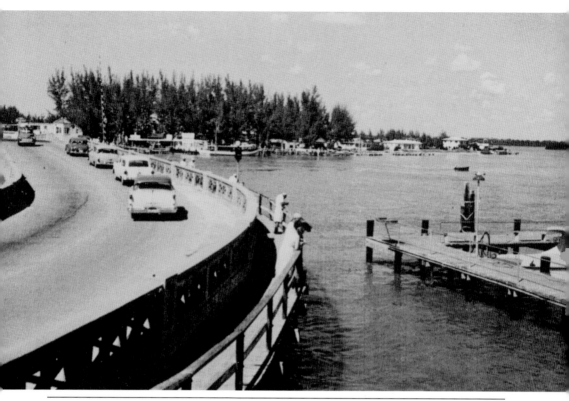

John's Pass's days as a fishing village began in the early 1900s, when famed fishing guide George Roberts settled at the north end of the pass. The bridging of the pass in 1927 accelerated development of what would become Madeira Beach. Docks and boathouses were built along the waterway on each side of the bridge to accommodate both recreational and commercial fishermen. Today tourists rather than fishermen line the boardwalk at John's Pass.

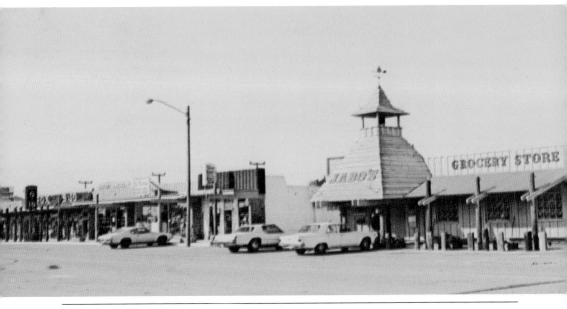

The creation of John's Pass Village in the 1960s began the area's transition from a fishing village to a shopping and tourist venue. The first stores in the village were typical shopping center outlets such as groceries, laundries, and five-and-dimes and served mostly local residents. Development of the village as a large-scale tourist attraction began in the 1980s with the completion of the boardwalk along the pass. New construction followed, along with more tourist-focused businesses such as souvenir shops, restaurants, and sightseeing boats that are the mainstay today.

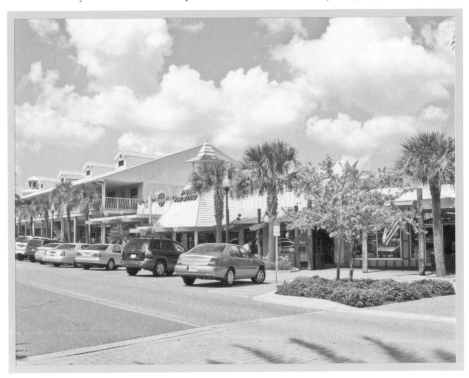

The Marine Arena was the first of the aquariums in the area, opening in 1953 at John's Pass. Billed as the "West Coast's Largest Attraction," it featured porpoise acts and a giant 50,000-gallon tank for viewing hundreds of marine animals. Faced with competition from the larger Aquatarium in St. Petersburg Beach, the facility shut down in 1965 but enjoyed a brief renaissance in the mid-1970s as John's Pass Aquarium. The building housed DeLosa's Pizza in recent years and is now the Wild Style resort wear shop.

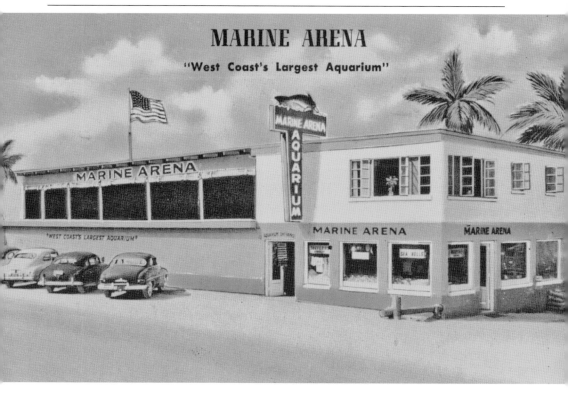

Welch Causeway was Pinellas County's first toll-free bridge to the beaches when it opened in 1926. The span linked the mainland to Mitchell's Beach, a tiny hamlet when purchased by real estate developer David Welch in 1924. Welch had dreamed up the idea for the bridge that some called "a bridge to nowhere." Mitchell's Beach would grow into Madeira Beach, and the narrow old drawbridge would continue to transport motorists over until its four-lane replacement opened in 1962. (Courtesy of Heritage Village Archives and Library.)

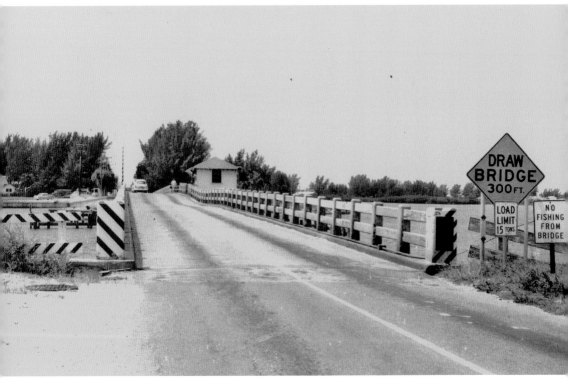

The city of Madeira Beach was born on August 8, 1951, with the merger of the towns of Madeira Beach and South Madeira. Town hall, which was located at 14509 Gulf Boulevard, became city hall and housed the municipal government offices as well as police and fire services. That location is now an office building. In 1965, the current municipal complex opened along the waterfront off of Madeira Way. (Courtesy Madeira Beach City Hall.)

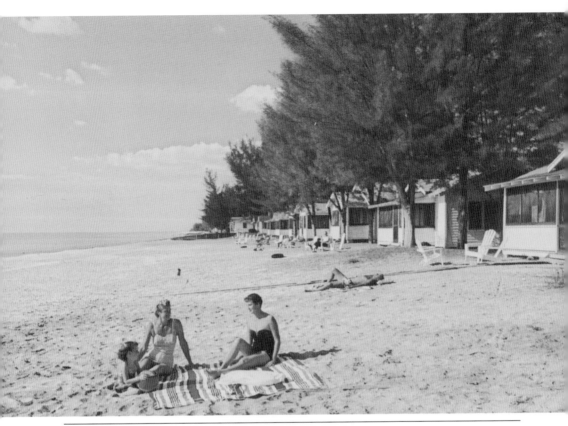

Sans Souci at 15208 Gulf Boulevard was typical of the mom-and-pop cottages that were popular along the beach until the motel era arrived in the 1950s. The usual cottage had a screened porch and one or two bedrooms. This property was the site of Madeira Beach's largest hotel, the Holiday Inn, in later years. That structure was demolished in 2004 to make way for the Sereno condominiums.

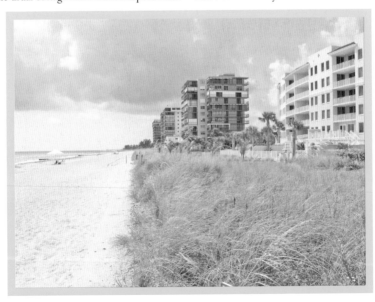

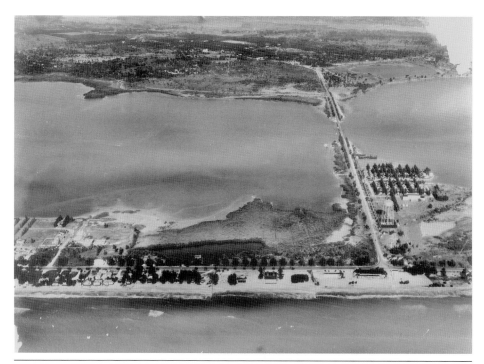

The early view of Madeira Beach, taken in the late 1930s, shows little development beyond a few tourist accommodations along the beach and a trailer park at the center right where the City Marina is now located. The Sans Souci cottages can be spotted at the lower left. Mangrove swamps and Lake Frances fill the area that now includes Madeira Way, Winn Dixie Plaza, and the city hall/library complex. The only structure still remaining is the log cabin, formerly the Snack Shack, at Archibald Park (lower center). (Above, courtesy of Arnold Alloway; below, J. Cook Photo.)

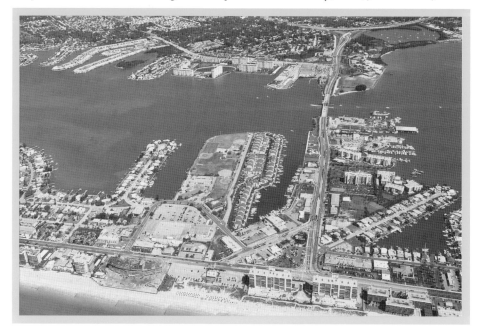

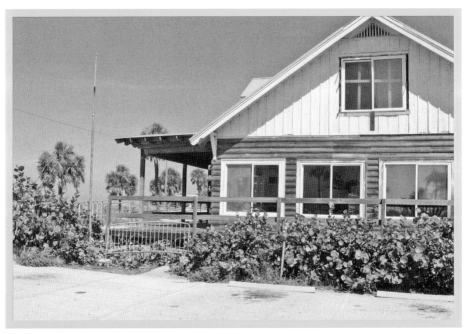

The log cabin located at Archibald Park dates to the 1930s, when it was exclusively reserved as a recreation and rehabilitation retreat for veterans from nearby Bay Pines Hospital. A Disabled American Veterans group later ran a light-food and refreshment stand there called the Snack Shack. Years of disuse and controversy preceded a move in 2006 to tear the cabin down. A determined effort by a group of Madeira Middle School students aroused public support to preserve the venerable structure. (Courtesy of Dottie Miller.)

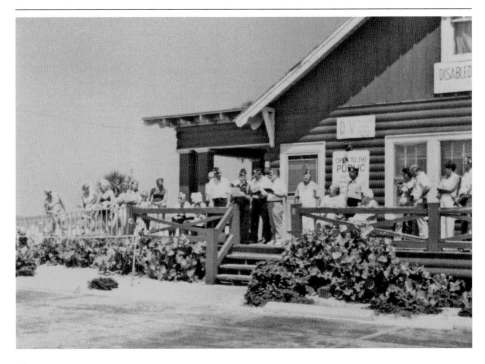

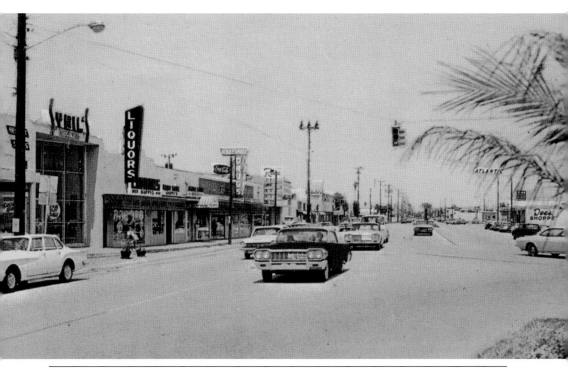

Gulf Boulevard was Madeira Beach's "main street" in the 1950s and 1960s. Retail businesses stretched along both sides of the busy thoroughfare and parallel parking was allowed in either direction. Today the stores on the west side are all gone, replaced by towering beachfront condominiums. The buildings on the right have not seen a dramatic change; there is still a gas station where the Atlantic was, and the dress shop is now a real estate office.

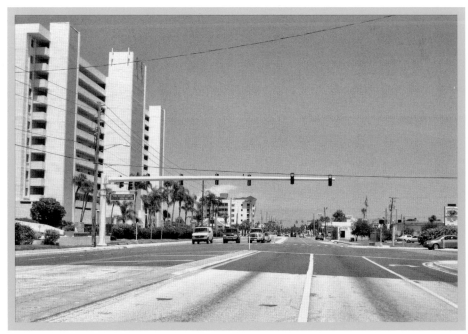

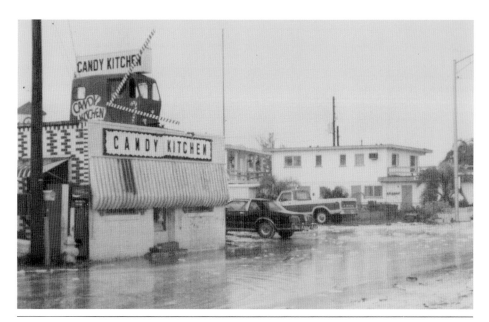

Ice cream, fudge, and candy of every description sweeten patrons' palates at the Candy Kitchen, a beach icon since 1950. Customers of all ages reenact a decades-long tradition when they line up for a treat on hot summer days. A profusion of color greets the eye on the inside, with candies filling the tall cases and mementos signed by happy customers on the walls and ceiling. Hurricane awnings shielded the sweets from damage during Elena's fury in 1985. The van atop the building was a fixture—not due to the hurricane winds. (Courtesy of Candy Kitchen.)

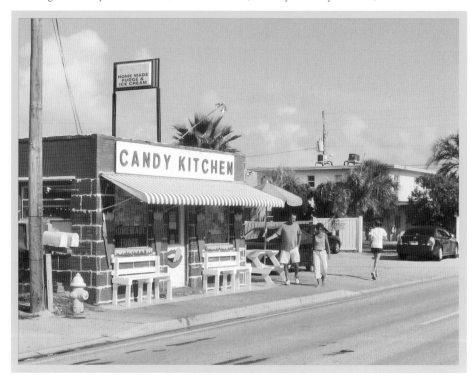

The famous Tides Hotel and Bath Club was the beaches' social center and a celebrity rendezvous during its 50-year run. The rich and famous guests included stars of stage and screen who rubbed shoulders with retirees and corporate partiers. The appeal included a fantastic beachfront setting away from the limelight, an Olympic-sized pool, top-drawer amenities, and an owner who promoted relentlessly with often outrageous stunts that drew reams of press coverage. The Tides condominiums are today home to many who hold fond memories of times spent at the fabulous resort.

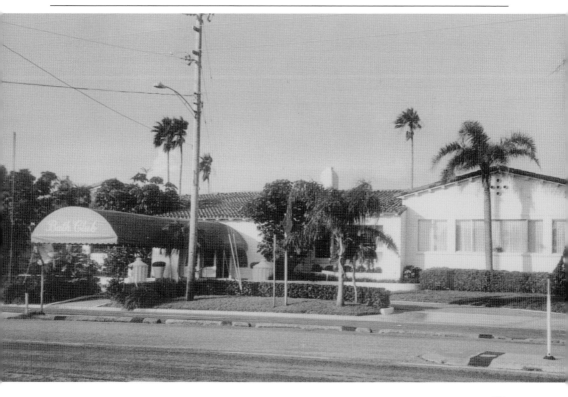

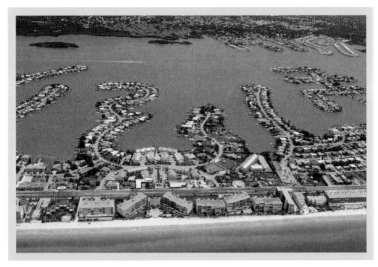

Social life of the north beaches was dominated for years by the famous Tides Hotel and Bath Club. The hotel hosted such luminaries as Marilyn Monroe and Joe DiMaggio, movie star Ronald Reagan, and director Alfred Hitchcock among others, while the Bath Club was the place for locally prominent socialites. The resort's appeal, and upkeep, faded in the latter years of the 20th century, and in 1995, the once renowned landmark was demolished. Today the luxury Tides condominiums' six structures dominate the local shoreline. ("Now" courtesy of J. Cook Photo.)

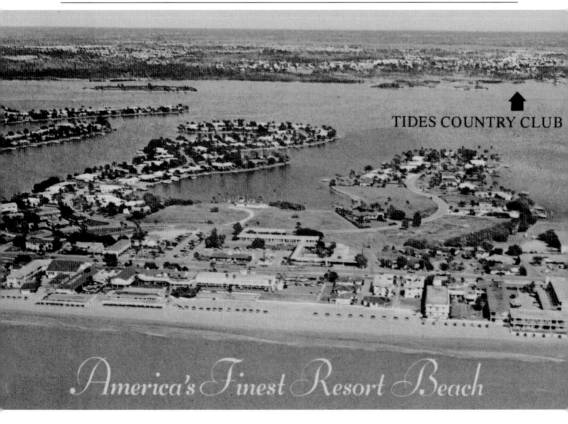

TIDES COUNTRY CLUB

America's Finest Resort Beach

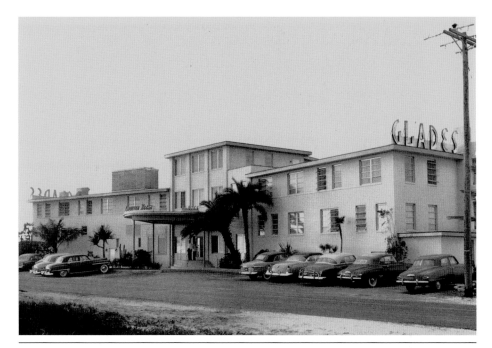

The Redingtons were home to another prominent resort, the Glades, located at 17350 Gulf Boulevard. The beachside resort was established around 1950, during the postwar tourist boom era, and sprawled over several acres. Accommodations surrounded an extensive courtyard area that featured landscaped grounds, pool, and shuffleboard courts. In the 1980s, the property was renovated to become the Grand Shores West time-share resort. (Courtesy of Heritage Village Archives and Library.)

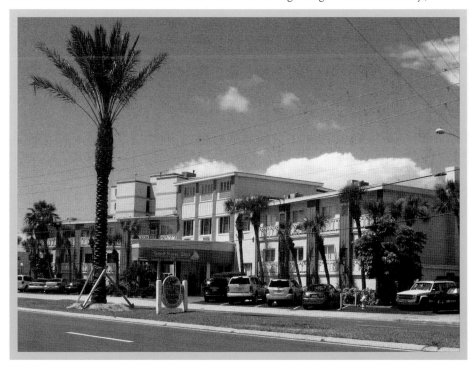

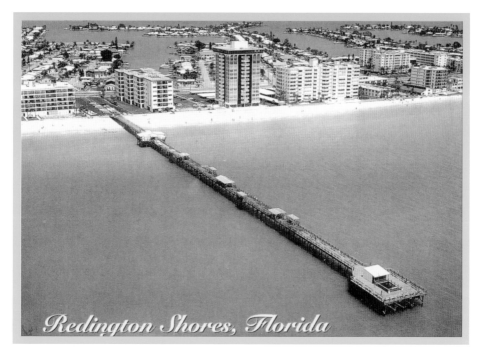

Redington Shores, Florida

Wooden fishing piers jutting into the gulf were a common sight along the beaches during the postwar era. Indian Rocks Beach at one time counted eight piers, both public and private, within its borders. The Redington Long Pier in Redington Shores is the lone survivor. The landscape fronting the vintage pier has changed dramatically since its construction in 1962. A scattering of low-slung 1950s-era motels has been replaced by almost wall-to-wall development, mostly high-rise condominiums. (Courtesy of Tony Antonious.)

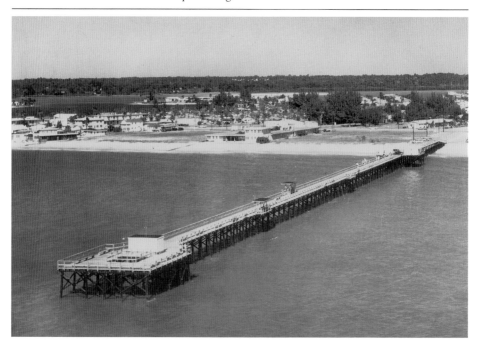

INDIAN ROCKS TO SAND KEY

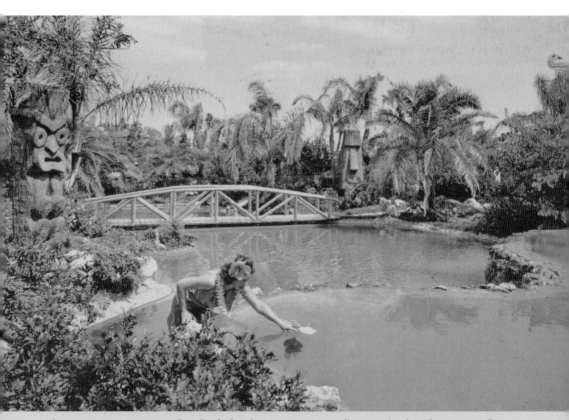

The year 1964 was a coming of age for the beaches, with the opening of several major attractions. None was bigger than Tiki Gardens, a nationally acclaimed Polynesian paradise that drew over a quarter-million visitors annually in its heyday. The tourist influx helped bring an economic boom to the northern beach strip, spurring construction of new motels, restaurants, and scores of service businesses.

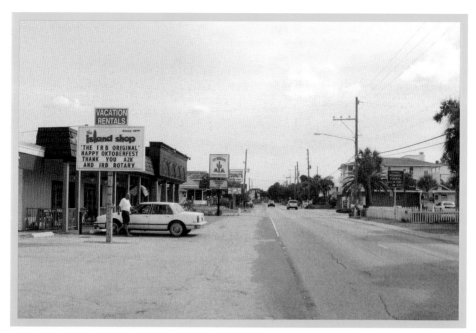

Gulf Boulevard was a sand trail when first cut through palmetto scrub in the early 1900s. The road was mostly deserted but it provided access up and down the barrier island and formed the basis for the beaches' "main street" of later years. These views looking south in Indian Rocks Beach are a dramatic reminder of just how much has changed over the past century. (Courtesy of Indian Rocks Historical Society.)

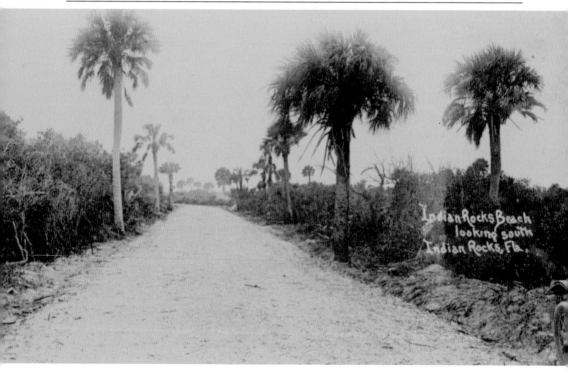

INDIAN ROCKS TO SAND KEY

The old wooden bridge across the Narrows at Indian Rocks was a busy place. Businesses clustered along the bridge approaches included the U.S. post office, a sundries store, and a fish market at the east end and the famed Indian Rocks Inn on the other end. The 42-year-old span was replaced in 1958 by the current Walsingham Bridge about a mile north. Only a historical marker and a few fragments of wood remain as a reminder of what was once the heart of Indian Rocks Beach. (Courtesy of Indian Rocks Historical Society.)

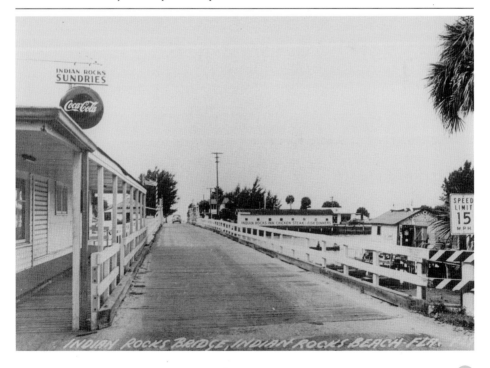

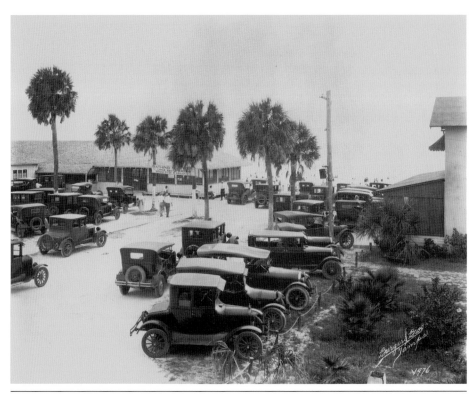

The Pavilion, later known as Brandon's Pavilion, was a longtime center for social activities on the beach. The 1925 photograph shows the Pavilion (left) at its prominent location at the end of the old bridge. The building on the far right was the Indian Rocks Inn, built in 1911 by Horace Hamlin, son of pioneer settler L. W. Hamlin. The Pavilion and Indian Rocks Inn were destroyed by separate fires in the 1960s and replaced by Fifty Gulfside and Happy Fiddler condominiums. (Courtesy of Indian Rocks Historical Society.)

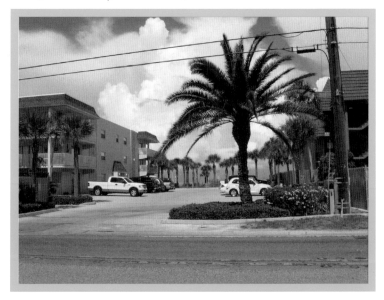

Unisex bathing suits have long gone out of style and automobiles on the beach are now taboo, but enjoyment of the beach remains the area's major draw. Numerous sand renourishments over the years and plantings of native vegetation have kept Tampa Bay's beaches wide and sparkling. Aside from contemporary fashion, the 1927 sunbathers at Indian Rocks show striking similarity to the beachgoers of today. A relaxing day at the shore is a pleasure that spans the years and generations. (Courtesy of Florida State Archives.)

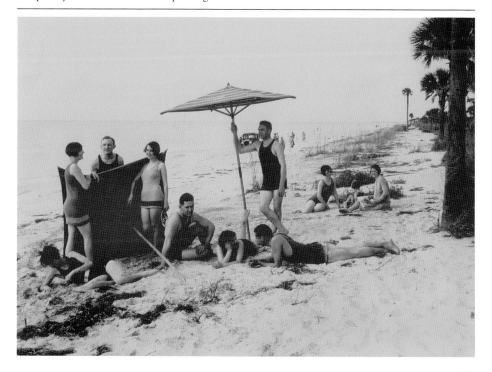

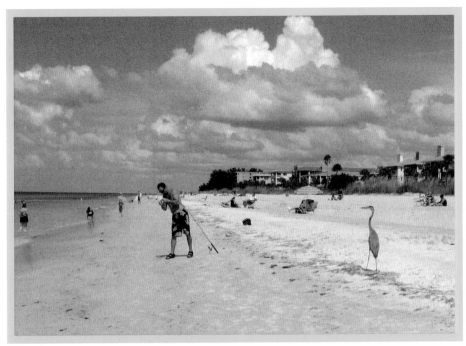

Fishing was a mainstay of the early Indian Rocks economy. The lines of mullet nets being dragged ashore contrasts with the occasional recreational fisherman seen on today's beaches. The construction of jetties along the beach put an end to the netting practice. Smoked mullet is still readily available in local fish markets, but the local smokehouses and processing plants have disappeared. A heron or egret, seeking an effort-free meal, will often serve as a companion to a lone contemporary fisherman. (Courtesy of Indian Rocks Historical Society.)

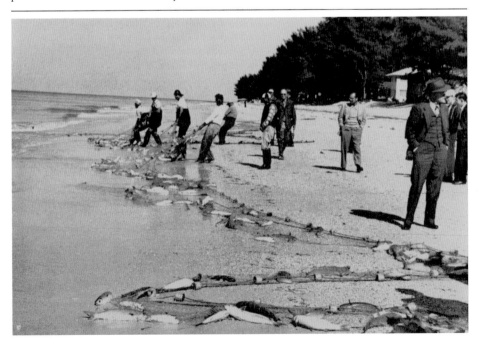

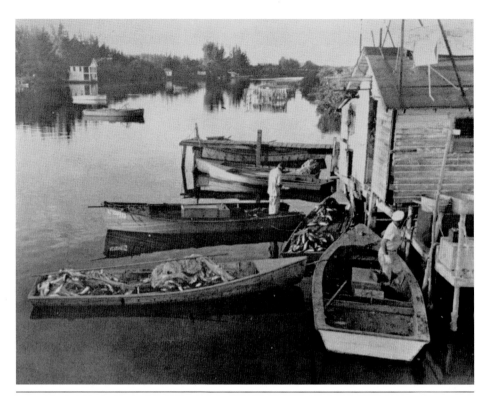

The day's catch is unloaded at Wyllys Ransom's fish house, located at the northeast end of the old Indian Rocks Bridge. Ransom's was one of several fish houses located along the channel over the years. Fishing-related pursuits provided an important livelihood for local residents. The only structure remaining is the Bie Boathouse at the left. (Courtesy of Indian Rocks Historical Society.)

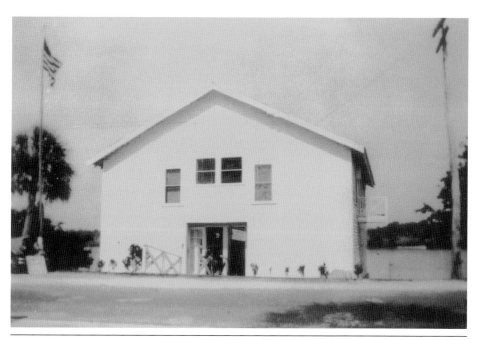

The Bie Boathouse has been a landmark at the entrance to the Narrows since 1911. It was constructed by citrus grower Harry Ulmer to house his speedboat *Miss Largo*. A trapdoor on the first floor is said to have been a transfer point for rumrunning done during the Prohibition era. In 1938, realtor Norman Bie converted the boathouse for use as a permanent residence for his family. Bie descendents currently use the structure as a family retreat. (Courtesy of Indian Rocks Historical Society.)

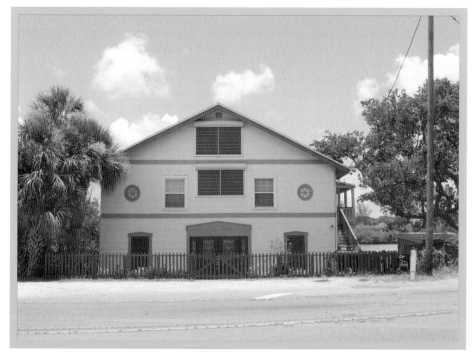

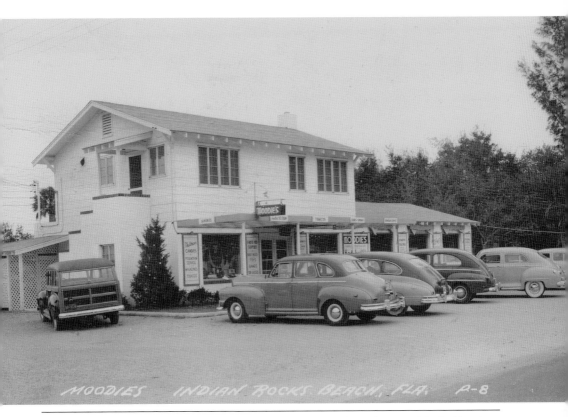

Moodies Drug carried just about everything a 1950s vacationer could desire, from cold drinks, reading material, and tobacco to cameras and beach toys. The soda fountain was often filled with teenagers who dropped by in their bathing suits. Ferman Moodie opened his drugstore, the first on the island, in the early 1940s. The building later housed Palmer's Steak House and then O'Neals on the Rocks before becoming the popular JD's Restaurant and Lounge. (Courtesy of Indian Rocks Historical Society.)

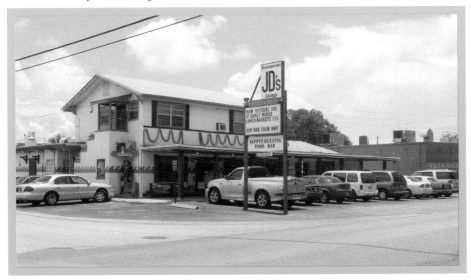

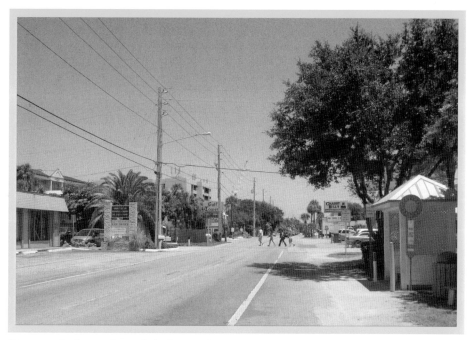

"Downtown" Indian Rocks Beach, looking north on Gulf Boulevard to Fourth Avenue, is shown here as it appeared in the early 1960s and today. Mambo's Restaurant, on the right, later became home to the famous Crabby Bill's. Dale's Bar (far right, now CVS Pharmacy) was built in 1939 and became known as "the nerve center of the beaches" during World War II. The tall bare trees are the skeletal remains of Australian pines destroyed in the 1962 freeze. (Courtesy of Indian Rocks Historical Society.)

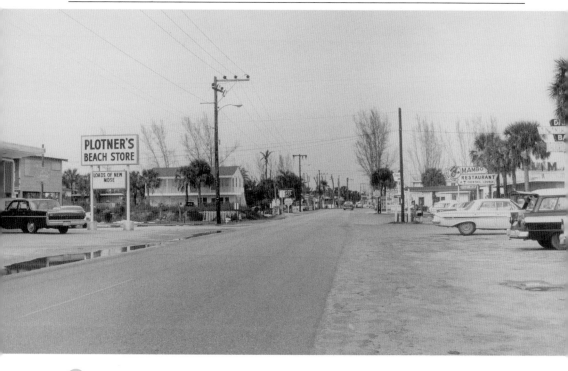

INDIAN ROCKS TO SAND KEY

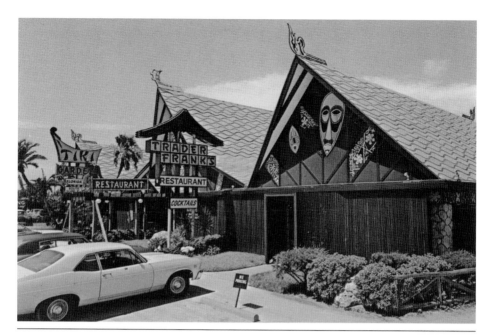

Visionary couple Frank and Jo Byars embarked on their Polynesian re-creation, Tiki Gardens, in 1964 following a fire that wiped out their gift emporium. A wonderland of towering tikis, lagoons, exotic birds, jungle trails, and twilight torch-lighting ceremonies emerged from their effort. The attraction drew over 300,000 visitors annually during its heyday years. Paradise died in 1992, a victim of theme-park competition. Now a county beach access parking lot fronts the fenced-off, overgrown former Tiki Gardens.

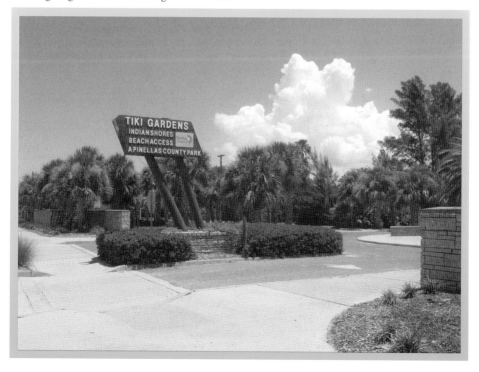

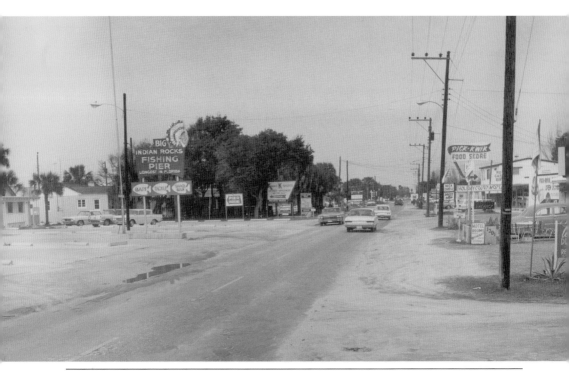

This Gulf Boulevard scene, looking north from Twelfth Avenue, shows the entry to the Big Indian Rocks Fishing Pier. The pier was billed as the longest in Florida when it opened in 1959, and it helped define Indian Rocks Beach's reputation as a fisherman's paradise. Many record catches were reported in the popular fishing tournaments held there. The wooden structure was destroyed by Hurricane Elena in 1985. Today a few pilings and parking lot remnants are the only reminders of the prime fishing destination. (Courtesy of Indian Rocks Historical Society.)

Pueblo Village was a unique shopping experience along the beaches. Opened in 1956 at the southwest corner of Gulf Boulevard and Fifteenth Avenue by brothers William and Joseph McNally, the building appeared to have been transported directly from the Southwest. A trip to Indian Rocks Beach was not complete without shopping Pueblo Village's eclectic mix of novelties, clothing, and Western-themed merchandise. A 40-year run as a beach icon came to an end in the late 1990s when Pueblo Village was succeeded by a condominium development. (Courtesy of Indian Rocks Historical Society.)

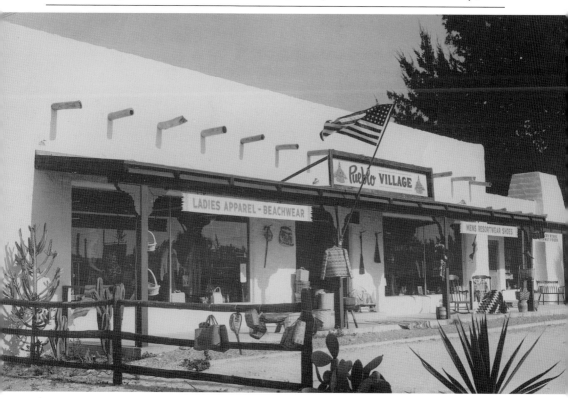

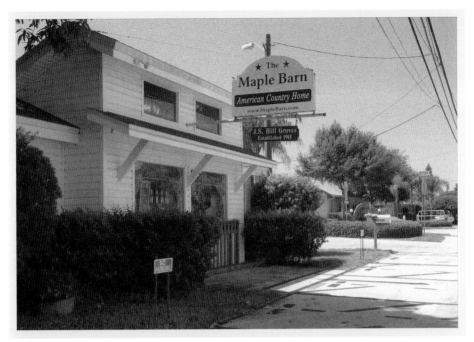

Citrus groves covered much of the mainland area that comprised Indian Rocks. In 1936, J. S. Hill opened a fruit packing plant at 10900 Oakhurst Road. Hill had bought his first acreage in 1915, and over the years his holdings grew to more than 60 acres. The groves have long given way to residential development, but the original building is still in use as a home accessories shop called the Maple Barn. (Courtesy of Indian Rocks Historical Society.)

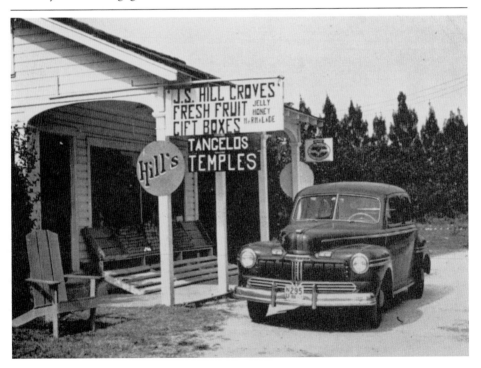

INDIAN ROCKS TO SAND KEY

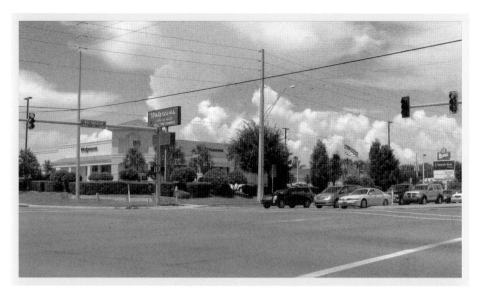

Visitors to the busy intersection of Walsingham and Indian Rocks Road find it hard to believe that the area was once covered with citrus groves. The packing plant and gift shop for Harry Ulmer's Indian Rocks Fruits was located where the Walgreen's now stands. On the grounds was Ulmer's famed Palm Garden Restaurant and Gardens, where diners could enjoy fine dining indoors or outside under the plentiful palms. (Courtesy of Indian Rocks Historical Society.)

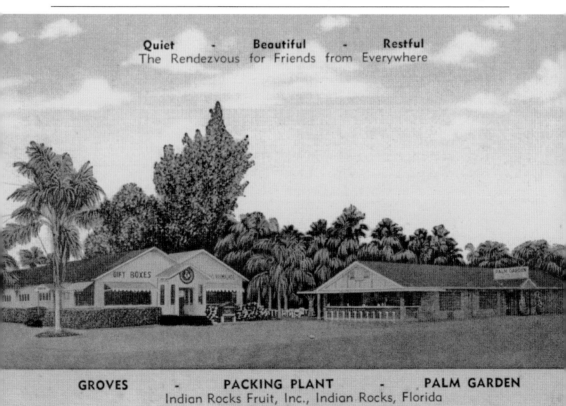

Quiet - Beautiful - Restful
The Rendezvous for Friends from Everywhere

GIFT BOXES

PALM GARDEN

GROVES - PACKING PLANT - PALM GARDEN
Indian Rocks Fruit, Inc., Indian Rocks, Florida

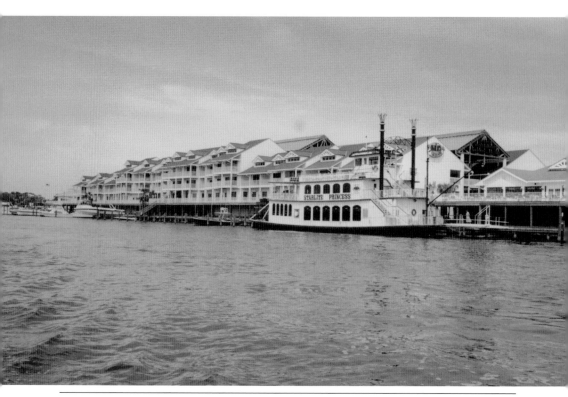

The rambling Holiday Inn Harbourside at Fourth Avenue and the Intracoastal was built in 1986 as Hamlin's Landing, named for a nearby ferry landing of the early 1900s. The complex featured a collection of souvenir and boutique shops, restaurants, and tourist accommodations. The paddle-wheel boat *Starlight Princess*, now at St. Pete Beach, offered dinner and sightseeing cruises along the waterway. In 1995, Hamlin's Landing converted to a Holiday Inn, and today it is operating as a condo-hotel. (Courtesy of Indian Rocks Historical Society.)

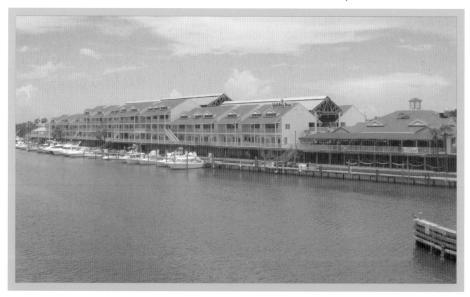

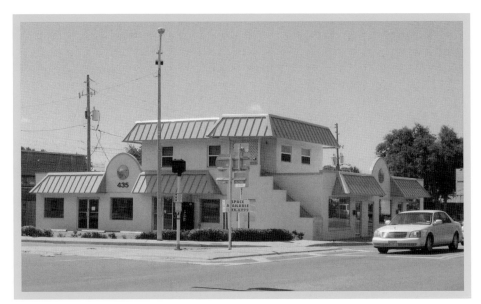

The busy corner of Walsingham Road and Gulf Boulevard was once home to the real estate offices of L. B. Moody, who played a prominent role in early Indian Rocks Beach development. Moody's first office was in a small cottage located at 127 Canal Avenue on the Yacht Basin. In 1952, at the height of the area's postwar building boom, Moody moved his business to this more spacious and visible locale. The retail complex also housed a relocated Cathedral Shop, a local landmark for many years near the old bridge. (Courtesy of Indian Rocks Historical Society.)

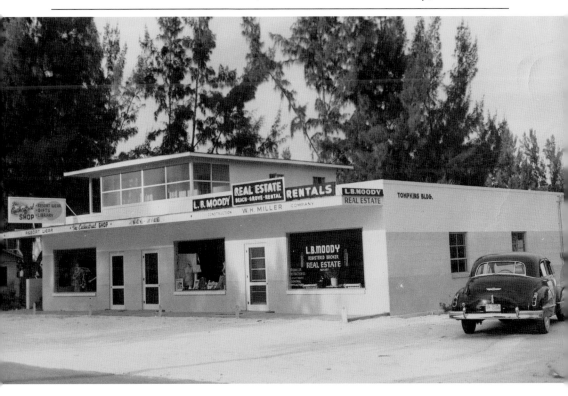

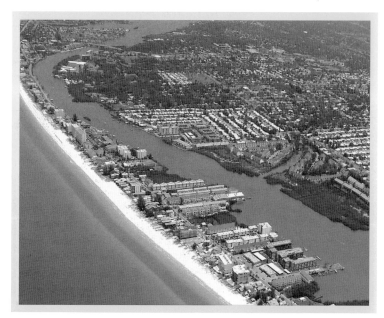

These views of the Narrows in Indian Rocks Beach show the tremendous redevelopment that has occurred since the 1950s. The earlier view shows the old bridge, which was constructed in 1916 at the site of a ferry crossing. The area surrounding both sides of the bridge was the center of business activity for early Indian Rocks. A few historic homes, such as the Bie Boathouse, Val's Castle, and the Hendrick house, remain to this day. ("Now" courtesy of J. Cook Photo.)

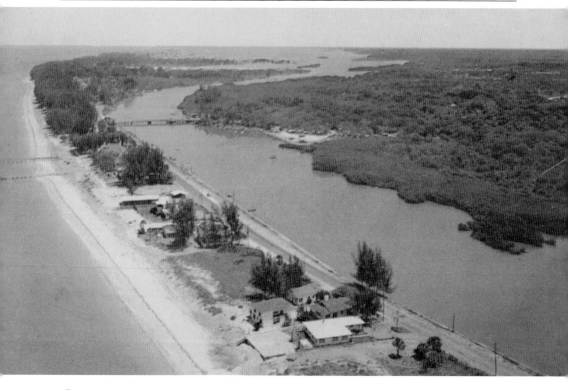

INDIAN ROCKS TO SAND KEY

The modest stone block structure at 760 Gulf Boulevard has survived storms and a changing marketplace that has taken out many such mom-and-pop establishments. The Little Food Basket appears open for business despite flooded streets following Hurricane Elena in 1985. The building housed the Tacky Turtle, famous for Cuban sandwiches, in recent years and is now the Kooky Coconut sandwich shop. The distinctive cane design was added by the latest owner. (Courtesy of Indian Rocks Historical Society.)

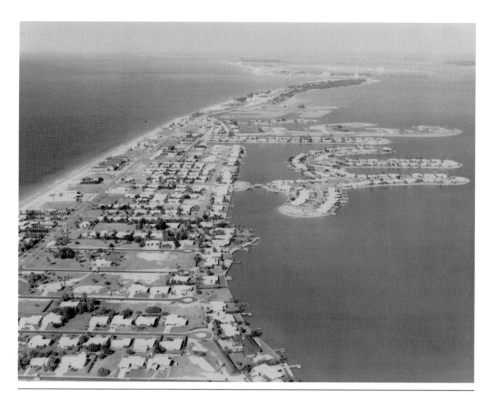

Dredging operations along the Intracoastal created thousands of acres of new waterfront property in Belleair Beach during the 1940s and 1950s. The new land fueled a postwar real estate boom that saw residential subdivisions spring up almost overnight along the newly created "fingers" jutting into the bay. The photographs trace progress of the development from bare sand to finished homesites that cover the landscape today. (Above, courtesy of Belleair Beach City Hall; below, J. Cook Photo.)

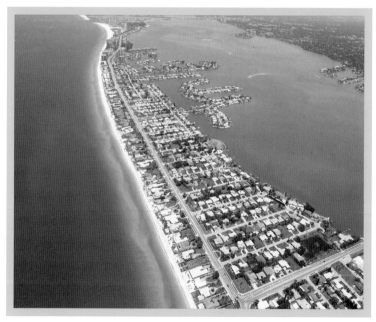

The Surf Apartments, now Nautical Watch, is one of the few remaining tourist accommodations on Belleair Beach. Long and low (there is a maximum three-story height) condominium developments dominate the largely residential city's gulf front. The three motels that are left date from the 1950s but have been modified and expanded over the years.

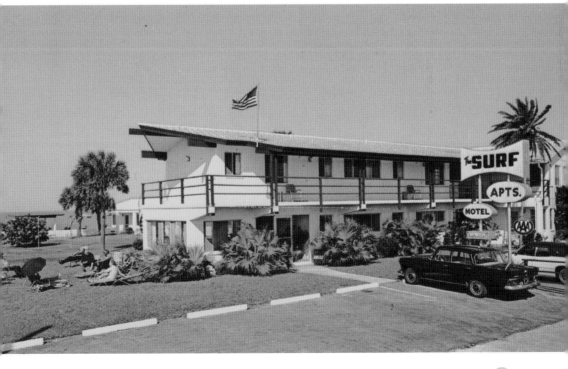

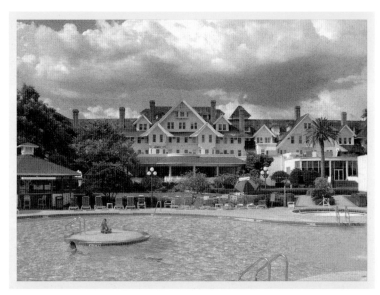

Henry B. Plant chose a secluded site on a high bluff overlooking Clearwater Bay near the Gulf of Mexico for his second grand hotel, the Belleview. Plant completed the edifice, pictured here, in 1897, bringing a spur of his railroad directly across the lawn to the hotel entryway. Top-class accommodations and amenities transformed the former wilderness site into a must-stop for the nation's rich and famous. Today the rambling Belleview Biltmore includes three wings that were added by 1924, as well as this original building that still retains its classic appearance. (Courtesy of Heritage Village Archives and Library.)

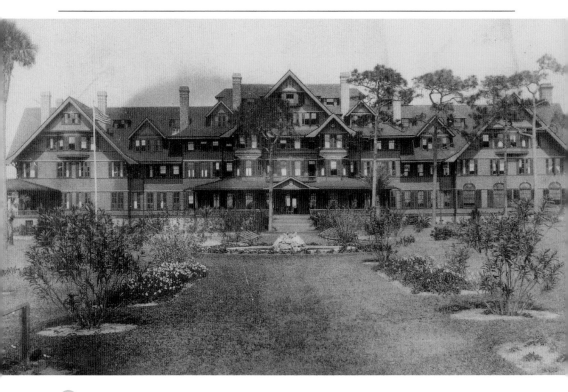

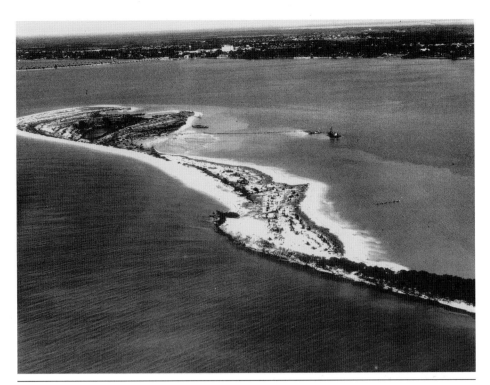

Sand Key, at the northern tip of the barrier island, remained a virtual wilderness, literally a sand key, until the mid-1980s. At that time, the City of Clearwater sold nearly all of the land to developers, retaining only a small portion near the upper end for a county park. Today rows of high-rise condominiums line the formerly pristine stretch of beach. (Above, courtesy of Heritage Village Archives and Library; below, J. Cook Photo.)

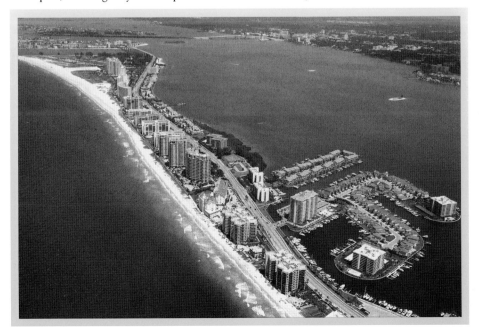

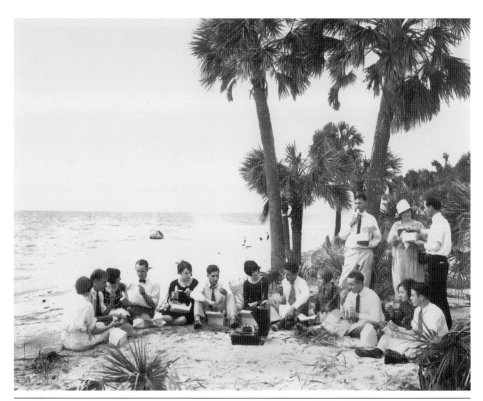

Guests of the Belleview enjoyed outings at the hotel's gulf-front property on Sand Key. The island was accessible only by boat, and groups were taken out in the *Cola*, the hotel's private launch. This 1926 scene shows picnickers enjoying a box lunch of bananas and other treats while being serenaded by their record machine. This same scene today includes the high-rise condominiums as a backdrop to currently popular beach activities such as surfing. (Courtesy of Florida State Archives.)

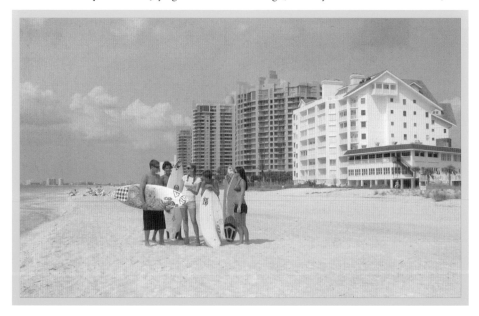

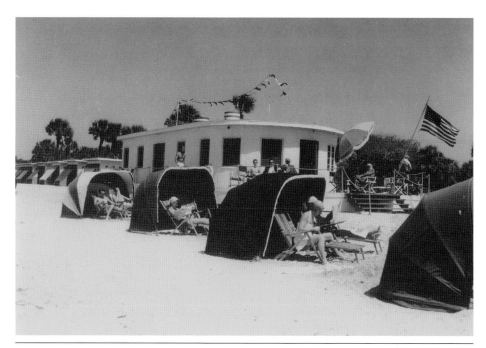

The building resembling a ship, constructed in 1941, was the Belleview Biltmore's beachfront cabana club. Guests could also relax in one of the rented cabanas. A larger facility constructed in 1963 provided space for weddings, banquets, and meetings and also housed a complete kitchen and bar. In the 1980s, the hotel sold most of the land to developers but retained a small slice of beach property. The Cabana Club Bar and Grill is now operated by the Belleview Biltmore on the site. (Courtesy of Heritage Village Archives and Library.)

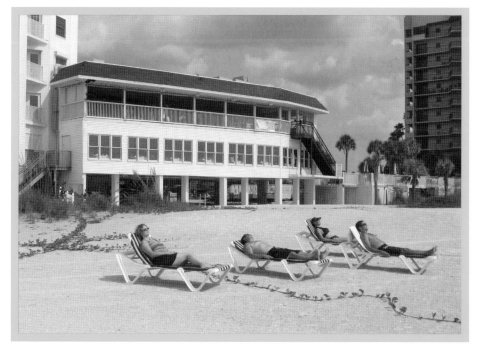

Eagles Nest Japanese Gardens was created in 1935 when Clearwater resident Dean Alvord hired internationally renowned horticulturist Fumio Hayakawa to turn his 65-acre bay front Belleair estate into an oriental botanical paradise. The resulting tourist attraction featured a teahouse, shrines, and pagodas in a lush tropical setting. During World War II, the gardens' popularity waned, as its Japanese connection had turned into a liability. Reopened in 1946 as Eagles Nest Gardens, the property was later subdivided into private residences. (Courtesy of Tampa–Hillsborough County Public Library System.)

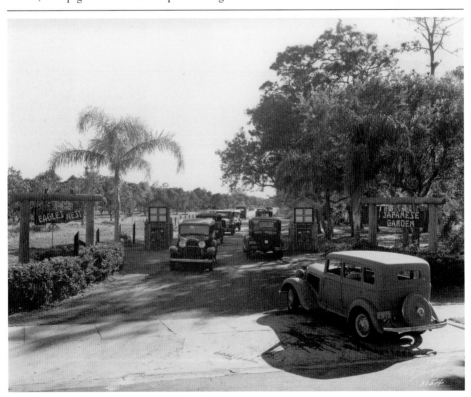

CLEARWATER BEACH

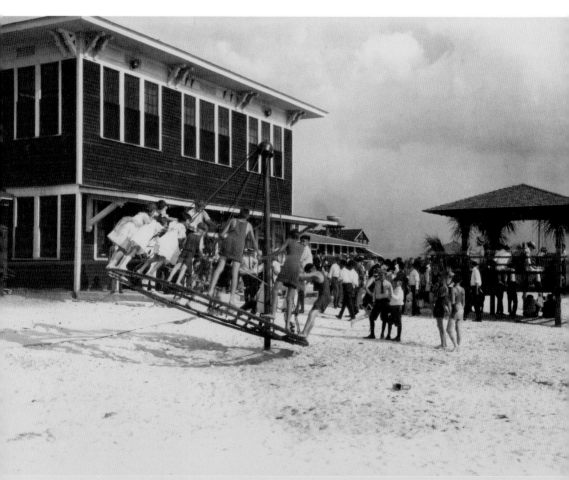

Clearwater Beach's prime attraction has always been, quite literally, the beach. The area's wide, pristine white sand beaches continue to gain national recognition. Beach pavilions were a welcoming sight to early tourists, offering a convenient place to change into beach attire, buy accessories, and perhaps even rent a bathing suit. The pictured Clearwater Beach Pavilion was the largest of the bathhouses on the island and was located near where the Palm Pavilion is today.

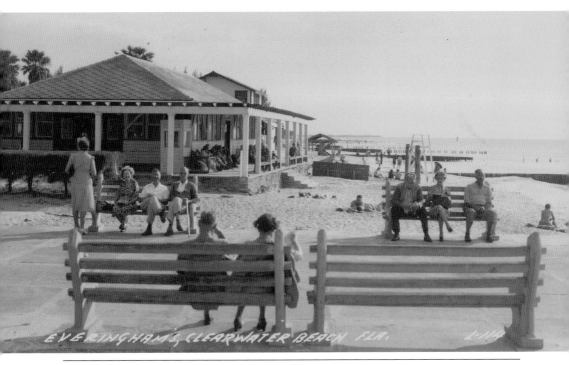

Beach pavilions were a focal point of activity along the waterfront during the early to mid-1900s. Everingham's was a popular Clearwater Beach attraction from the 1920s until it was torn down in 1950 to make way for the Pier 60 development. Today a souvenir/snack shop located in that spot at the foot of the pier is still attracting beachgoers.

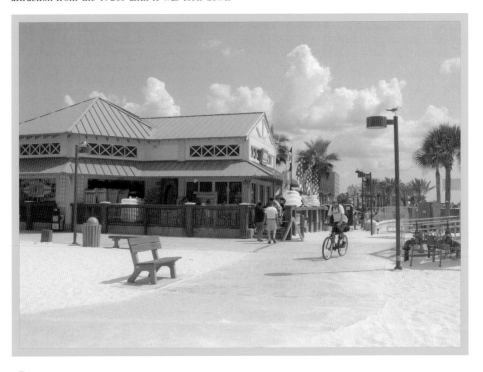

CLEARWATER BEACH

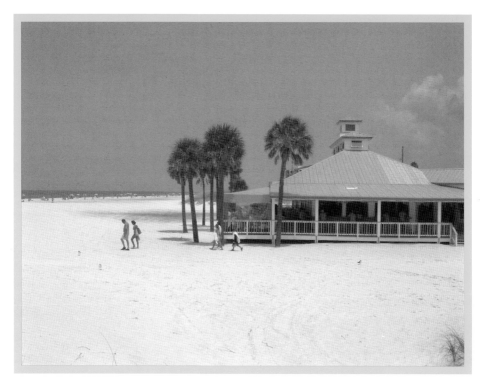

Palm Pavilion is the only survivor among numerous beach pavilions that were once a common sight along the shoreline. Built in 1926, the Palm Pavilion has evolved from its bathhouse days into the current informal restaurant and bar. Most of the dressing rooms were torn down in the 1960s to make way for a putt-putt golf course, which has since been removed. These days, grouper sandwiches and live entertainment are the focus.

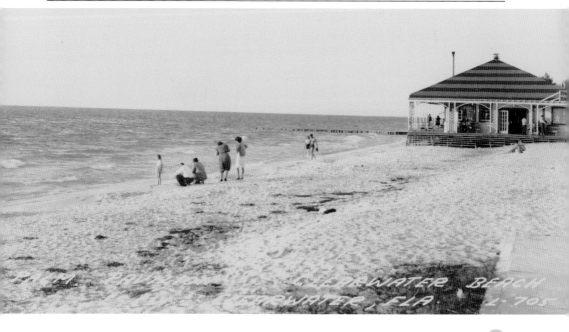

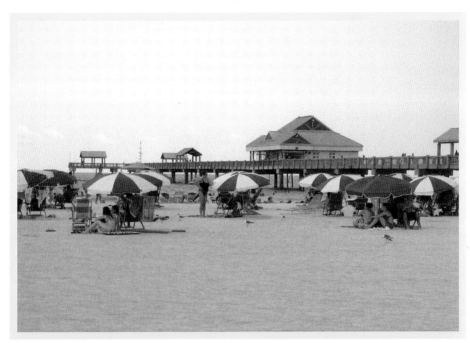

The Clearwater Beach pier heritage dates to 1912, when the City of Clearwater included construction of a municipal beach pier as part of a $40-million bond issue. The structure was often crowded with sightseers, who arrived in their automobiles and used the beach as a parking lot. Today visitors vie for a spot to park their rented beach umbrellas. (Courtesy of Clearwater Historical Society.)

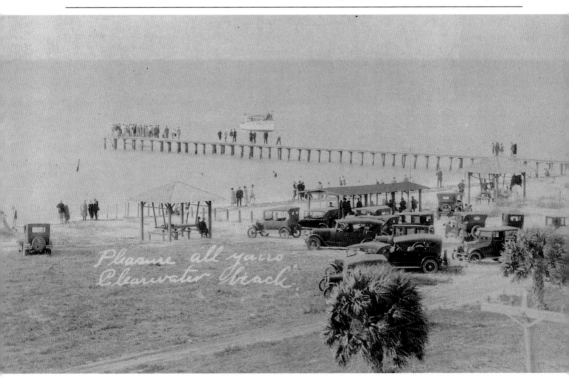

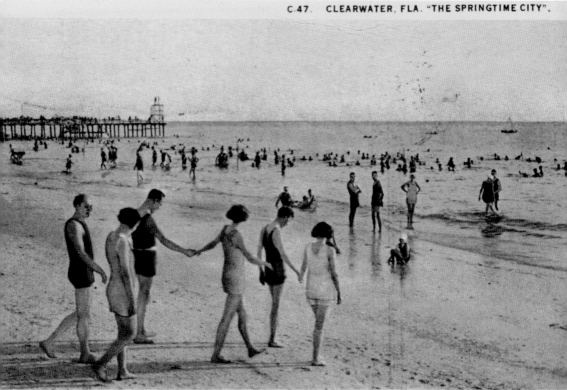

364. BATHING IN THE GULF OF MEXICO, FLORIDA. 115211

The 1912 pier was an established and popular attraction when this postcard photograph was taken in 1926. Its reach into the gulf though is dwarfed by Pier 60, the improved and extended structure that reenergized the Clearwater Beach tourist scene in the 1960s. The first Pier 60 amenities included a freshwater, heated, Olympic-style pool. Today sunset celebrations with musicians and artisans, along with 300 varieties of fish to catch, have helped make the attraction the area's top-drawing recreation venue.

Clearwater Beach

The Clearwater Marina was built in the early 1950s to accommodate the postwar surge in recreational boating. In addition to marine service facilities, the complex also was home to the Sea-O-Rama, a tourist attraction featuring sea-life exhibits. In later years, the marina has housed businesses catering to tourist interests, including souvenir shops, restaurants, and a nautical antique shop. The docks offer visitors a variety of sea experiences, including dinner and sightseeing cruises and deep-sea fishing boat excursions. (Courtesy of Florida State Archives.)

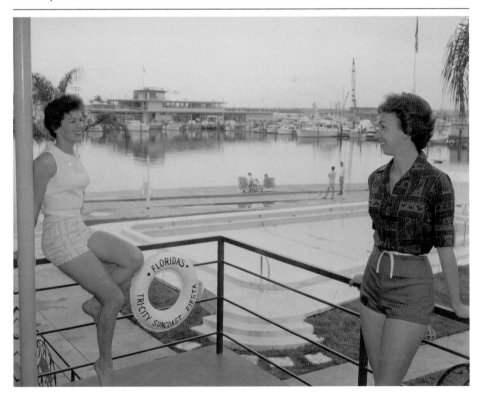

Completion of the Million Dollar Causeway from downtown Clearwater to the beach in 1927 helped fuel the boom times that would establish Clearwater Beach as the area's premier tourist resort. The causeway replaced a rickety wooden bridge built in 1916 at the beginning of the automobile age. A modern bridge constructed in 1962 relegated the Million Dollar Causeway to a fishing pier. In 2005, a new $70-million high-level bridge opened, and all remnants of the celebrated Million Dollar Causeway were removed.

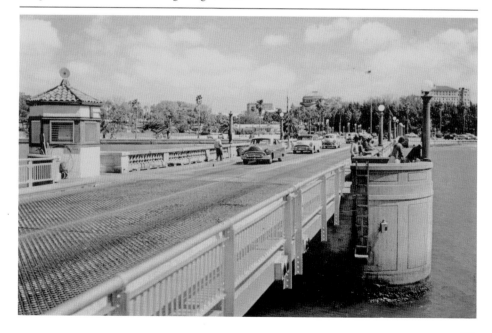

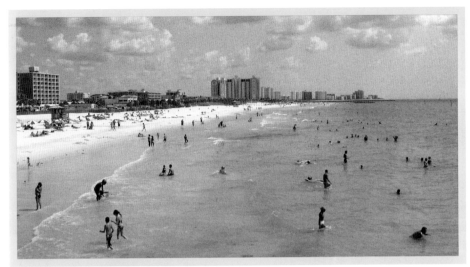

Clearwater Beach's prime attraction has long been its renowned public beach, which has been consistently recognized as one of the finest anywhere. During the late 1800s, excursionists would arrive on the island by boat to picnic and perhaps venture into the gulf. By the post–World War II tourist boom era, vacationers of all descriptions had discovered the wide and expansive stretch of pristine sand. The crowds continue to flock to what "Dr. Beach"—Dr. Stephen Letherman—named "The best city beach on the Gulf of Mexico."

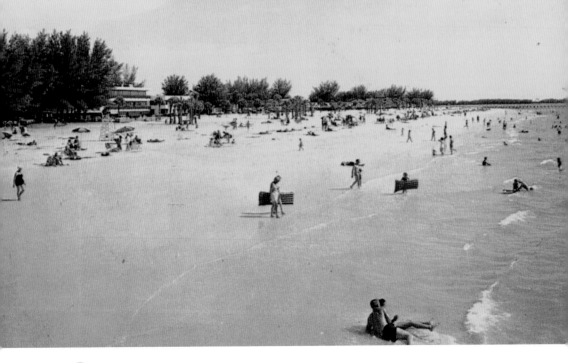

Clearwater Beach, Florida

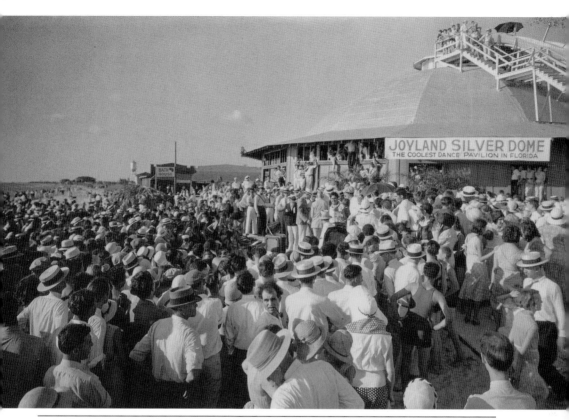

A trip to the beach in the early 1900s often included entertainment options. Joyland Silver Dome at Clearwater Beach was a popular amusement destination, featuring a giant waterslide, dance pavilion, and arcade games. The slide was dismantled in the 1930s when the building became a clubhouse for an adjacent trailer park. In 1948, the unique structure was remodeled, a second floor was added, and the famous Sea Shell Hotel was born. The Sea Shell was taken down in 1972 to make way for the Clearwater Beach Holiday Inn, now the Hilton resort. (Courtesy of Tampa–Hillsborough County Public Library System.)

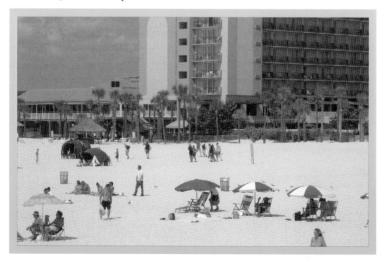

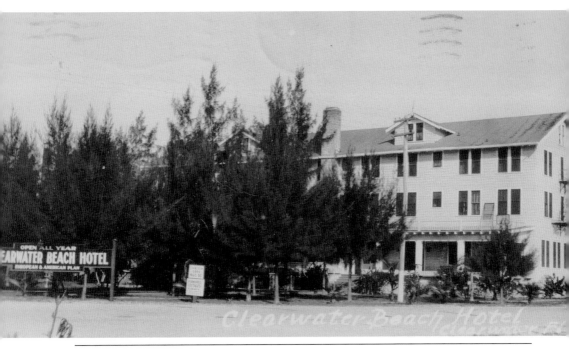

The Clearwater Beach Hotel had a lineage that stretched back almost as far as the community's roots. The hostelry began life as a beach cottage in 1917 and by the 1920s had expanded to become a major seasonal resort. The rambling wooden structure was rebuilt in the late 1970s but continued to draw praise from its many repeat visitors. The end came in 2005, when the hotel's latest incarnation came down to make way for the Sandpearl Resort. Opened in 2007, the Sandpearl has incorporated the old hotel's bar and historic dinner bell as a link to its storied predecessor. (Courtesy of Clearwater Historical Society.)

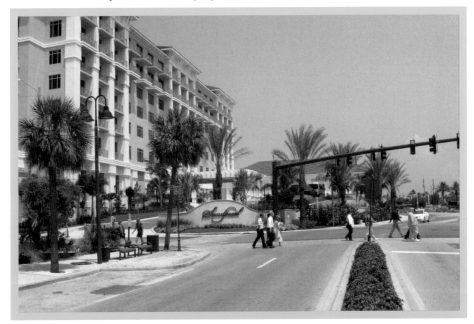

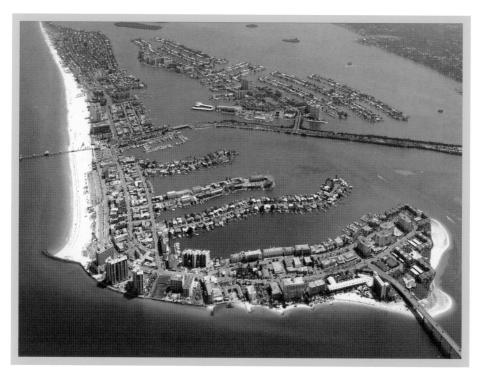

Development of Clearwater Beach during the decades following World War II is clearly shown in these aerial views comparing the 1950s with today. Sand fingers at the center right off the causeway have become Island Estates residential community. The barrier island strip facing the gulf was fully developed by the 1950s, but that development is radically shifting from mom-and-pop motels and businesses to large-scale, high-rise condominiums. ("Now" courtesy of J. Cook Photo.)

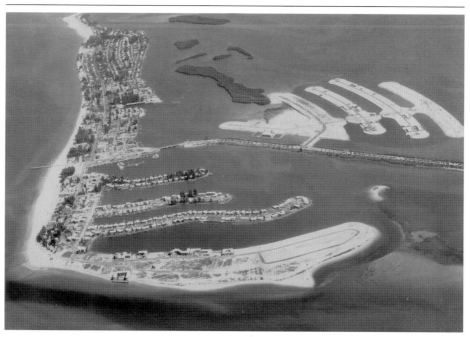

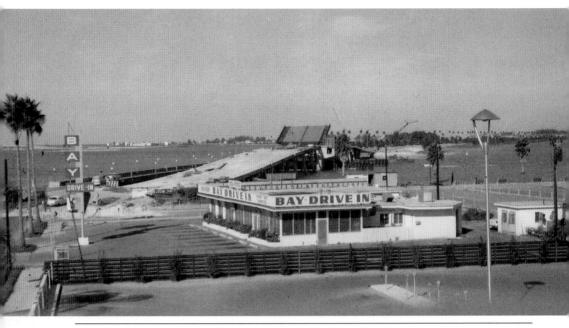

Bay Drive-In, located at the foot of the causeway bridge, was a popular hangout during the hot-rod era. Shown here during the construction phase of the new bridge in 1962, the Bay continued to pack them in for years until it was eventually driven out of business by the mega-fast-food chains. Today the site lies under the new high-level bridge near Harborview Center and is slated to be developed into a marina. Longtime residents wistfully recall the eatery's famous $1 fish dinners. (Courtesy of Heritage Village Archives and Library.)

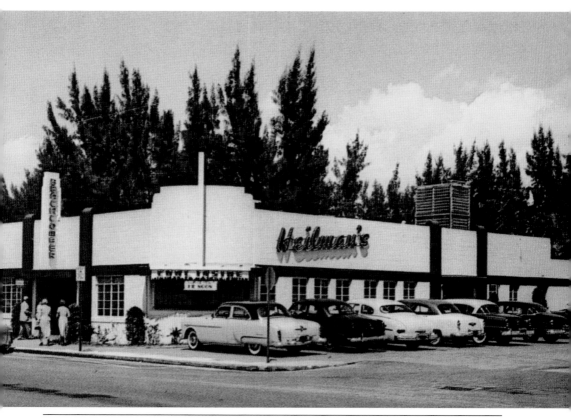

Generations of residents and tourists have enjoyed gracious fine dining at Heilman's Beachcomber, a Clearwater Beach institution since 1948. In the early days, the restaurant was famous for its "Back to the Farm" chicken dinners and air-conditioned comfort.

Through the years, the Beachcomber has achieved landmark status, maintaining its Old Florida style and look. Some features that have endured to today are the traditional piano bar and white tablecloths to complement their classic menu.

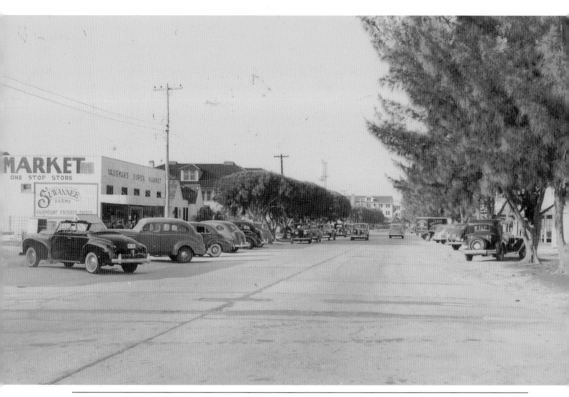

This view, looking north on Mandalay Boulevard from the Beachcomber Restaurant (not in the photograph), reveals a busy commercial thoroughfare in the early 1950s. The landmark Clearwater Beach Hotel can be seen in the distance. Today the Sandpearl condominiums (left, under construction) stand on the site of the famous Pelican Restaurant. Palmetto palms have replaced the now-taboo Australian pines as landscaping. (Courtesy of Clearwater Historical Society.)

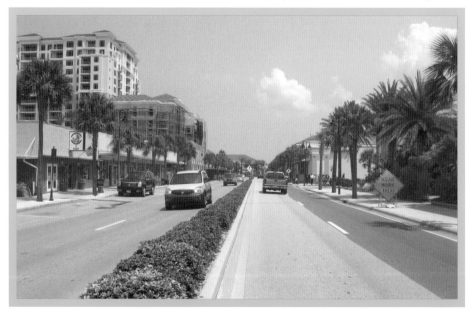

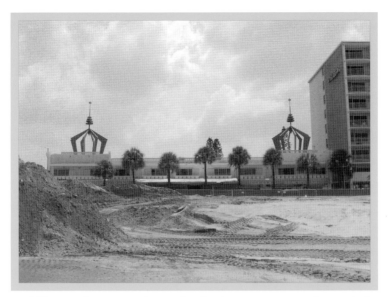

The fantastical blue cupolas topping the Beach Tower Apartment Motel no longer fit with the landscape of the high-rise development projects that dominate today's Clearwater Beach. The 1960s postcard, showing the Beach Towers in its heyday, urges guests to "Hurry back—We now have color TV." The modern photograph shows the abandoned vintage motel being readied for the wrecker's ball.

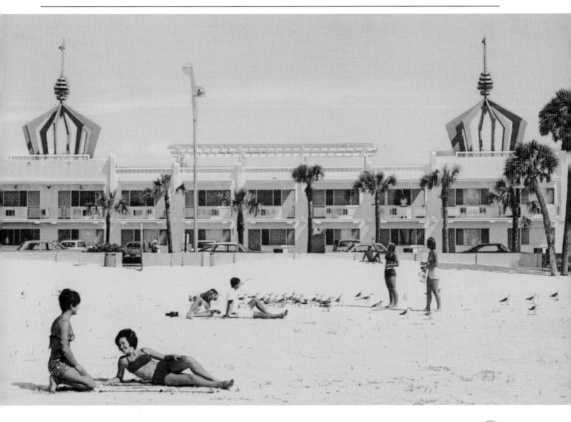

Across America, People are Discovering Something Wonderful. *Their Heritage.*

Arcadia Publishing is the leading local history publisher in the United States. With more than 3,000 titles in print and hundreds of new titles released every year, Arcadia has extensive specialized experience chronicling the history of communities and celebrating America's hidden stories, bringing to life the people, places, and events from the past. To discover the history of other communities across the nation, please visit:

www.arcadiapublishing.com

Customized search tools allow you to find regional history books about the town where you grew up, the cities where your friends and family live, the town where your parents met, or even that retirement spot you've been dreaming about.